# HAUNTED
# MANTORVILLE

# HAUNTED MANTORVILLE

## TRAILING THE GHOSTS OF OLD MINNESOTA

## CHRISTOPHER S. LARSEN

Haunted America

Published by Haunted America
A Divisoin of The History Press
Charleston, SC 29403
www.historypress.net

Copyright © 2011 by Christopher S. Larsen
All rights reserved

Images are courtesy of the author unless otherwise noted.

First published 2011

Manufactured in the United States

ISBN 978.1.60949.109.3

Larsen, C. S. (Christopher Sterling), 1966-
Haunted Mantorville : trailing the ghosts of old Minnesota / Christopher S. Larsen.
p. cm.
ISBN 978-1-60949-109-3
1. Haunted places--Minnesota--Mantorville. 2. Ghosts--Minnesota--Mantorville. I. Title.
BF1472.U6L377 2011
133.109776'153--dc23
2011022062

*I dedicate this book to all those who explore the mysterious world of the paranormal. To the investigators who face fear and stretch the boundaries and comfort of our limited reality.*

# CONTENTS

# ACKNOWLEDGEMENTS

First and foremost, I'd like to thank the people of Mantorville. Their openness and willingness to investigate the unknown has always been an inspiration to me. In particular, I'd like to thank Paul Larsen (no relation, although he could easily be an older brother), Theresa Hoaglund and Ann Driver. Without their assistance, this book would have been boring and nothing but a paperweight (and perhaps cannon fodder).

It also goes without saying that many thanks go out to Twin Cities Paranormal Society (TCPS). This organization's patience, knowledge and willingness to find time to investigate Mantorville has been supernatural to say the least. This book would be pointless without a team like TCPS keeping things honest and real. I'd especially like to thank Julie Panaro, Mike and Lily Sweeney, Dan Firestone and, most importantly, Will Ventling and Tam Prose.

I'd also like to thank Ben Gibson and Ryan Finn at The History Press for their insight and, very importantly, patience. Writing books can sometimes take more time than one thinks, but a good publisher will keep you moving forward!

Lastly, I'd like to thank you, dear reader. This book is meant for you, whether you're a seasoned veteran of the paranormal or someone who simply has a strong fascination. Regardless, I hope you enjoy the book and end up with a better appreciation of the things that go bump in the night.

Introduction

# SEARCHING FOR THE TRUTH

Do you believe in ghosts? Whenever I get on the subject of ghost hunting—or "paranormal investigation," more politically correct—I always like to ask a person, "Do you believe in ghosts?" It's a great question and always hard to answer. What's interesting is that very few people say, "Absolutely not." Most are either a definite yes or a solid maybe.

For those of you who are living in the "absolutely not" group, I doubt you're reading this book of your own free will. Unless, of course, you're doing it for purely scientific reasons. I'm okay with that. After all, maybe this book will convert you, leading you to the dark side.

For those of you who are in the "definite yes" camp, kudos to you. You apparently have had some type of paranormal experience that has convinced you that ghosts exist. You need no further proof—it has already stared you in the face. This book may not enlighten you in any way, but it may entertain you. Hopefully you can relate to the stories within and the investigations mapped out that occurred.

Lastly, for those on the fence in the "solid maybe" group, this book is for you. You see, I tend to be in that same group as well. Sure, there have been times in my life where I have confronted hard-core paranormal evidence and have been converted. But as the weeks and months pass by, that belief dwindles, and I'm left sitting on the fence once again.

Sadly, it seems to be extremely difficult to capture that all-encompassing proof—that elusive picture, recording or footprint (if partaking in the festive monster-hunting lore). It always seems to be just out of reach or too blurry or

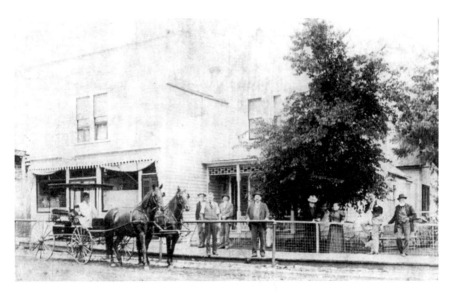

Picture of downtown Mantorville in the mid-1800s, perhaps showing a few locals who would one day haunt the town. *Courtesy Dodge County Historical Museum.*

the sound isn't quite clear enough. Perhaps there's a reason for that. Maybe the supernatural is beyond our realm and doesn't want to be found.

In the paranormal investigation and monster hunting that I've done, I've seen a recurring theme: evidence is always personal (and sometimes *very* personal). Sure, every once in a while you capture an EVP (electronic voice phenomena) with a strange ghostly voice or a picture with a haunting shadow. Better yet, you capture a video of a door closing by itself or maybe even the Holy Grail of paranormal investigations: a full-body apparition. Regardless, no matter how many friends and skeptics you show your proof to, they are not entirely amused.

It makes you wonder if we will ever find enough evidence that will turn the world upside down on the paranormal front, transforming the supernatural into the natural. When will there be enough proof? Do we need Mr. Ghost to be interviewed by David Letterman, Oprah or Jay Leno? Part of me believes that even then most of the world would still not believe. Perhaps there will always be three groups—the believers, the nonbelievers and the wanna-believers.

This leads me to the basis of this book. I have asked the question, "Do you believe?" to myself hundreds if not thousands of times throughout my life. And my answer always comes back the same: I'm not sure. I'll admit

that I'd like to believe, but the logic and science I grew up with seem to battle and win every time—the scientist within me conquers all, demanding a hypothesis and hard evidence. Facts speak loudly; ideas of the mind are but a whisper in the wind.

Yet I would like to know once and for all if ghosts exist. Watching *Ghost Hunters* or *Ghost Adventures* makes me think that the paranormal is definitely real. There are so many instances where they capture some awesome evidence. But what if they are faking it? How can I know for sure—should I go and meet with Jason and Grant or Zach, Nick and Aaron? And even then, will I be convinced by their direct word of mouth? Sadly, I would have to say no.

In the end, the proof is in the ectoplasmic pudding. If you don't take the time to look for the paranormal, well, it's pretty rare for it to just drop in your lap. The only obvious way to know for sure that ghosts are real is to find them on your own—firsthand experience. What better proof is there than that?

That pretty much sums up this book. It's about me and my search for the truth about the paranormal. The setting is in the town of Mantorville, which I believe to be one of the most haunted towns in Minnesota. Will I find any paranormal activity? Who knows. Hopefully, by the end of my expedition, and the end of this book, I can rest comfortably knowing that ghosts are real. Of course, if I truly knew that they were all around us, while I'm writing this book (and while you're reading it), living as invisible as a cellphone signal, every now and then transcending into our world, I'm not sure how well I'd actually sleep at night.

Regardless, there comes a time in your life when truth is more valuable than life itself—or perhaps more than the reality in which you comfortably live. Maybe that happens as you get older, knowing that your time on this planet is limited. The question I should ask is, "Do you *dare* to believe?" The times in my life when I have come close to believing in supernatural things, having blundered into something that was most likely a paranormal incident, I easily found myself *not* wanting to know. I found countless reasons why I should ignore what I had just experienced. I'd rather be watching scary movies from the comfort of my couch, thank you very much.

Yet our separated world of living room comforts, detached from the reality that's out there beyond the television set and fabricated reality shows, may in fact be far greater than we ever imagined. What are the boundaries of reality? Where do we go after we play our games and wear our masks of life? Where did we come from? Is life *truly* eternal?

Perhaps my reason for hunting ghosts stems from those kinds of questions. If by chance I could find real proof that ghosts exist (albeit probably within the confines of my own mind), what would my life be like then? What decisions in life would you make, knowing for sure that an eternal afterlife waited for you—that there is an energy belt of beings beyond our materialistic madness called earth?

I know that for some fortunate souls out there, faith is all they need for believing in the afterlife. My hat goes off to you. Sometimes I feel that life would be much easier to swallow if I were more blind and ignorant to the inner workings of reality—to brush aside the wonderings I have of quantum mechanics, time travel possibilities and, yes, ghostly hauntings. Perhaps the world would be a better place. To live life with blind faith may, in fact, open one's eyes to a much better world.

Fortunately, or unfortunately, I was dealt a hand full of questions and confusion. Try as I may, I cannot avoid the fascination of life (and its counterpart, death) and the questions it creates. In the end, I am inquisitive; I wonder about life and the duality of death endlessly. I'm sure many of you do the same, which is probably why you're reading this book now. Or maybe you haven't bought it and are reading it in the aisle of your local Barnes & Noble.

So if there is life, there is death, right? All things must pass, yet all things must come to be as well, right? With that in mind, I wonder if there will be a day when we finally get the ghostly proof so many paranormal investigators have been searching for. Audio and video of ghosts and shadow people become a dime a dozen. Will there actually be a day when ghosts live comfortably among us? Perhaps that day is near—very near. Can you say *Day of the Dead?*

So this book is about ghosts and the truth that surrounds them. And how does the quiet town of Mantorville come into play? Simply this: Mantorville is not all that quiet. Being one of the oldest towns in the Midwest, it has plenty of history. And with history come legends, myths and, you guessed it, ghosts.

There are countless towns and cities in Minnesota that I could have written about; many places have their own legends and hauntings. But as fate would have it, I am drawn to Mantorville. Or perhaps Mantorville is calling me there. Either way, I feel it's important that I explore the paranormal in this little southeastern town, tucked a ways off Highway 14, with Highway 56 cutting through the heart of it.

Another reason for choosing Mantorville is convenience, I suppose. Being that I live in Rochester, I can travel to Mantorville in a matter of minutes.

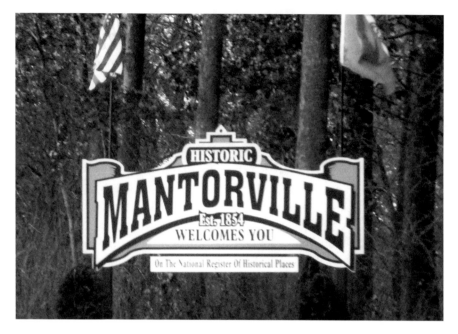

A welcoming sign for Mantorville as you drive into town from Highway 57, near Cemetery Road.

That makes it easy for stopping in to do research and investigations. And with it only being about forty-five minutes from the Twin Cities, it's not too far for others to visit, which I highly encourage.

Thankfully, I will not be alone on this ghost quest. I have the comfort of a real paranormal investigation team, the Twin Cities Paranormal Society (TCPS). Having its members available to do investigations has been invaluable. Kudos to TCPS for being available and interested in what goes bump in the night down in Mantorville.

Regardless of your background in the paranormal, I hope you will enjoy this book. As I have indicated, it's about ghost hunting number one but also providing some history of southeastern Minnesota, in particular Mantorville, a town that's been around for more than 150 years. Of course, no ghost book would be complete without stories of the paranormal, and I have countless incidents reported from the area.

I hope that this book helps you better understand the process of investigating the paranormal. For those who have not gone on any ghost adventures, it should be an exciting read for you. And for anyone who is a

seasoned veteran of the paranormal, I'm hoping that it will at least entertain you, helping you to relive some of your own ghostly experiences.

Lastly, I feel that it is important to mention that I've taken a somewhat lighthearted approach to the book. After all, who wants to read about straight gloom and doom? Besides, I believe that you have to have a good sense of humor when dealing with the paranormal, what with it being so spooky and all. Sometimes the best remedy for fear is humor. Laughing in the face of death fits well with paranormal investigations—of course, in this case you are taking the phrase literally.

So please, take some time and come along with me on this journey into the truth about ghosts. The setting is the town of Mantorville, but it could really be Anywhere, USA. Ghosts, I'm told, are for the most part the same worldwide. The hauntings described within this book could be describing those in your neck of the woods. Just change the name of the town, and I'm sure the stories and investigations will sound hauntingly familiar.

# FIRST IMPRESSIONS

I can still recall the first time I set foot in the small town of Mantorville. My wife, Nancy, and I, as newlyweds married no more than a year, were looking for the perfect place to call home. This was back in the early '90s, when life seemed so much easier and simpler. No cellphones, no Internet and no *American Idol*—come to think about it, I can't imagine how we survived. One thing, however, that hasn't changed is the paranormal. It seems that hauntings and creatures of the night are ageless.

Back when I was a teenager, I had that zest for otherworldly experiences. Unfortunately, for the most part the world beyond ours didn't have a zest for me. I thought deeply about the possibility of aliens, monsters and ghosts. I never went on any investigations, but I contemplated their existence quite often. For the most part, it wasn't until I came to Mantorville that I got up close and personal with the paranormal.

As we crossed the bridge into town, I was blown away by the cozy, comfortable feeling that Mantorville gave us. It seemed like this could be the place in which to spend eternity. It just had that perfect "live here forever" feeling. Of course, little did I know that there were some ghosts feeling the same way.

The term "ancient" might be another way to explain the feeling I got coming into Mantorville. Not in a bad way, mind you. The sensation most likely stemmed from the 150-year-old buildings located along Main Street or possibly Fifth Street or elsewhere around town. You had the feeling like time stood still, allowing you to take a break from the rat race in Rochester and

An old, spooky house that the author nearly bought at one time.

other, much larger cities. Things felt old and permanent, in a good way. It felt eternal and simple, definitely a place to settle down in and enjoy.

Still, I felt a presence of something unusual there as well, something altogether different. I couldn't put my finger on what it was at the time, just that it was an odd feeling. But nothing that would prevent me from living there of course!

Nancy and I were both excited to check out the house for sale. It was on the edge of town, south of the river, out west on County Road 12. We took a left off Highway 57, just before the bridge, heading west back out of town. It was an old house, to say the least, or at least some of it was old; it certainly had seen better days. A fixer-upper to be sure, but that didn't matter to me. I was pulled into its mesmerizing ultrarustic ambiance. I was ready to move in, no questions asked. It was clear to me that the house had been added onto several times over the years, making it appear like a little miniature Winchester house, with staircases seemingly heading to nowhere and windows opening to walls.

Some rooms in the house didn't quite meet up, making you take a step or two walking into them, like the room was an afterthought. The realtor tried to gloss over the rugged details of the paint-peeling window frames;

cracked, wind-etched glass; or doors that didn't quite close. I was beaming with excitement as I gave my wife that look of "Let's buy it right now!" Of course, she returned my euphoric gaze with a "You've got to be kidding," or maybe she was saying, "What planet are you from?" The realtor, of course, could sense my excitement, which is always a bad situation when it comes to buying things. Impulse purchases are usually a disaster.

Needless to say, while I was pulled comfortably into the ambiance of the old house, Nancy was not. Being that she has always been the saner one between us, I quickly agreed that we'd keep looking for a better and less humble abode, one with fewer things to fix up. But I couldn't help but wonder if there was some invisible force at work on me, even back then, luring me to Mantorville like a siren in the woods. The town's charm was very catchy indeed.

Still, there was a strange feeling that I had while meandering from room to room in that old house, like something was there with me. I'm not saying I felt like there were ghosts among us; it was more like there were people there—lots of them. The house felt seriously lived in, with countless cousins, brothers, sisters, grandmas and grandpas, like a grand Thanksgiving feast get-together in November—complete with turkey, mashed potatoes, gravy and the all-important cranberry sauce.

A new bridge over the Zumbro River coming into town, replacing the old one from the 1800s.

It felt like I belonged there, comforted by the invisible presence of the many phantom individuals that seemed to follow me from room to room as I investigated my potential new home. It was certainly an odd sensation, knowing that reality only showed myself, Nancy and the realtor in the house. Yet it felt much bigger than that, like something otherworldly was watching us, like an invisible party had started, welcoming me to the town, perhaps.

To this day, I still struggle with explaining the feeling I had during my first visit to Mantorville. Regardless, a lasting impact was forged inside me, a deep connection to this ancient town, one beckoning me to come back. Perhaps the feeling was based on centuries-old living, from the Native Americans who had inhabited the land before the East Coast settlers.

Years passed before I returned, and it was once again not anything related to reasons of the paranormal. I was older, perhaps a little wiser, but still not living with a deep-seated curiosity of the spooky realm. Sure, I wondered about the odd feeling I had at the old house I had visited in Mantorville years ago and whether it would come back. Sure enough, that same feeling hit me while crossing the bridge on Highway 57 back into Mantorville—a comforting, surreal "home again" feeling. Yet some confusing and uncomfortable thoughts lurked in the back of my head—or maybe it was the backseat of my car.

It was the fabulous Marigold Days, back in the late '90s. It was the perfect fall weekend, with the leaves on the trees beginning to change, the wind becoming a bit chillier and the warm sun radiating high above. My wife and I decided that it would be great to visit Mantorville. At the time, we were living in Rochester, so the trip would only take a few minutes. There would be lots of things to do. Her favorite was exploring all of the antiques and flea market paraphernalia. Mine was, of course, simpler: food and beer (not necessarily in that order).

Marigold Days started back in the 1960s and has been going strong ever since. What do you expect, with events such as fishing contests, arts and crafts, quilt and flower shows and the all-important bingo. A down-home festival wouldn't be complete without someone screaming "Bingo!" across the tent. But let's not forget the grand parade, either. Marigold Days is definitely a huge event in Mantorville. It seems as though they may have some special connection with marigolds.

I did a little research on the marigold flower, curious as to its background and origin. As it turns out, the little flower has quite a big history. The marigold is known as the "Herb of the Sun" and is symbolic to passion and

creativity. This goes well with all of the arts and crafts that are celebrated during the festival.

The Welsh, as it were, believed that if the marigolds didn't open early in the morning, a storm would be coming soon. I'm not sure how true that statement is, but I believe that there could be *some* truth to it. Nothing magical, mind you. More scientific, in that a flower may stay closed if it's cloudy out in the morning, which could be the case if there's a big storm coming. Or maybe there is something more mystical going on. It makes me want to grow a few marigolds.

Marigolds have also been grown for love charms, used in wedding garlands. And on a more psychedelic note, marigolds were thought to induce psychic visions of fairies if rubbed on the eyelids. Now there's a tantalizing research project. Of course, I don't condone this behavior. Although I'm thinking that anything rubbed on your eyelids would probably produce a euphoric incident.

In other cultures, the flower has been added to pillows to promote prophetic and psychic dreams. Not sure about you, but I feel that drifting off to sleep snorting potentially narcotic aromas could leave you in a dangerous drug-induced coma. I'd stick with a generic and sterile cotton pillow, or maybe down-filled. Just make sure that the geese weren't eating marigolds.

Lastly, marigolds are apparently associated with lions and the astrological sign Leo. Early Christians named the flower "Mary's Gold" and offered the blossoms to the foot of St. Mary's statue. In other religions, the flowers are offered up to the Hindu gods Vishnu and Lakshmi. The marigold is also thought to be sacred among Aztec Indians, who could be found decorating their temples with the flower.

As you can see, there appears to be more to the flower than one might expect. It's no wonder that Mantorville celebrates the pristine blossom! Of course, the festival simply meant excellent food to me. Can you say cheese curds and turkey legs? I wonder if there's a sautéed marigold recipe?

The big event for us next was the flea market (or bazaar). Little did I know how "bizarre" it would get. There were so many antiques and crafts to traverse through, and we spent a good hour here and there contemplating whether the items we found would look good in our living room. (This reminds me of the story about the antique church pipe organ for sale down in Iowa that we almost bought—until we realized that its size made it impossible to display anywhere but our front yard.)

Everyone was so friendly at the event, but the kiosk that stood out the most for me was the one with dream catchers. A Native American woman (or at

least I assumed she was Native American, what with her dark bronze skin and colorful, Aztec-looking necklace and bracelets) selling intricately made dream catchers. What caught my eye the most was her, well, one eye. She wore a battered, brown leather patch over her left eye. Her hair was mostly a grayish-blue, flowing wildly in all directions, like she had recently been electrified.

"Care for a dream catcher?" she asked me in a crackly, uneven voice. She reached over and twirled one of her finely crafted leather-wrapped devices, fabricated with care to trap bad, naughty dreams. I pondered a moment how it let the good ones through. Angelic tollbooth perhaps, payable via a pocket full of good deeds? "Dream catcher sir?" She looked closer at me, leaning forward, and then reached for a supersized one. "You might need something bigger. Makes you sleep better at night."

I thought perhaps she was talking to someone else, but I could see her gaze was fixed on me—or maybe *through* me. It felt like her one eye busily etched a searing hole in the backside of my head. "Who, me?" I replied.

"Ayup." She winked, but I couldn't tell if it was a wink, or maybe just a blink, since she had just the one eye visible.

"Cool!" my wife said. "Aren't these cute toys?" She picked one up and began twirling it from the string between her fingers.

The old lady snatched the dream catcher out of my wife's hands, quicker than I would have imagined for a woman of her age. She scowled at my wife and then snapped, "They're not fir playing with."

She turned back to me, smiling and showing her uneven and Dalmatian-like brown and white patchy row of teeth. "Dream catcher?" she repeated, pushing the large one at me.

"I think she likes you," whispered my wife while she nudged me in the side.

"Heard that!" piped the old lady, sneering at my wife. "May be old, but not deaf!" She poked a finger at Nancy and asked, "You gonna buy one?"

I didn't like where this was going. Number one, I didn't believe in any silly dream-catching thing. Sure, in theory it sounds pretty cool. It's believed that the leather and string woven artifacts originated with the Ojibwa Chippewa tribe in the Minnesota-Wisconsin area. They would tie strands of sinew string around a frame of bent wood. The wood was in a round or teardrop shape, very similar to how a snowshoe would be woven.

Originally, the dream catchers were used as charms to protect sleeping children from nightmares. Legend has it that the dream catcher will catch one's dreams at night. The bad ones get caught in the webbing and are burned up in the morning by the rising sun. The good dreams find their way

to the center of the dream catcher and then float down the attached feather. This way, only good, happy dreams get through to you. But I wondered if it would protect you from a Wendigo (a flesh-eating spirit monster, supposedly originating from Native American legends).

"Dream catcher?" she repeated again, this time louder. I caught a whiff of worked leather as she waved it inches from my face.

"I think we'll pass," I replied quickly, forcing her arm away from me. I was surprised by the strength in her arm. "Thanks anyway."

I waited for her to protest or come up with another angle on how to sell this thing to out-of-town tourists. I expected her to become angry, perhaps throwing a few obscenities at me under her breath. Instead, she just smiled, with a grin that seemed to be filled with deep wisdom. Then she shook her head and said, "Your loss." She turned away, looking for other potential customers.

What did she mean by "your loss"? Years later, I wondered if she saw something in me, something about my curiosity with the unknown. Would I *need* a dream catcher? Would it help me through my quest of the paranormal? To this day, I can't say that I believe in dream catchers. Then again, I finally purchased one. Not for me, mind you—one for each of my boys. They have theirs hanging in their rooms, protecting them from the evil spirits during the night. And who knows—perhaps I am being protected by the residual effects, sleeping quietly down the hall. I have to admit that the bad dreams seem to have disappeared.

We toured the town, trying hard to forget about the strange Native American lady at the flea market. Or perhaps she was a gypsy? It wasn't until recently that I learned that there were, in fact, gypsies in Mantorville. Records dating back to the 1880s reference a gypsy camp situated south of the Zumbro River in Mantorville. For me, gypsies conjure up thoughts of horror movies such as the original *Wolfman*, starring Lon Chaney Jr. The most recent adaption of *The Wolfman*, starring Anthony Hopkins, was pretty good, too. I wondered for a moment if the old woman I met at the flea market was a descendant of the original gypsies? Possibly. Then why would she be selling Native American dream catchers?

Over the years, however, history has taken on more meaning to me. Probably because every year that goes by makes me more a part of it. But standing on Main Street in Mantorville, gawking at buildings, many about 150 years old, well, I felt pulled into them. Or perhaps there was something more—something *mysterious* happening. The Opera House, in particular, lured me closer, beckoning me to enter into its history.

"Something amazing about this building," I said to my wife as I kicked the steps leading up to the main entrance, like I was kicking the tires on a new car. Only this car wasn't new. It had been around the block a multitude of times. I pondered a moment, staring up at the second-story windows and wondering what scenes had played through the old building. Not just the ones on the stage, but behind it, and in front—I bet the building had a year's worth of stories to tell.

Being the writer wannabe that I was, I thought that perhaps there would be a way to write about the Opera House, as well as the rest of the town. Little did I know that it would happen someday. And perhaps that's what was drawing me in to this town. The town, with all of its endless stories to be told, was beckoning me to come in and learn a few of them and then, in turn, give them back to others. Perhaps that's what many of these ghostly apparitions are saying: "Come hear us! We are here and want the world to know us!"

As I turned away from the Opera House, I thought that I saw something in the second-story window—a shadow of some sort. Was it just my imagination? At the time, I had not caught the paranormal bug; I had no desire to go tromping around at night with the lights off, looking for things that go bump. But perhaps the shadow was the one with the desire, or maybe it planted a seed in my subconscious, one that grew over the years until it was time to harvest and hunt the paranormal.

Sometimes, I believe that it is not always us looking for the ghosts and goblins. Sometimes *they* are the ones looking for *us* (intelligent hauntings only, mind you). But there's apparently only a few of us who are open to the idea that something exists beyond our world—at least when it comes to the subject of ghosts. Are you one of them? I believe that there's something there. But I'd like much more proof—hence the reason for my crazy ghost-hunting expeditions.

My wife and I finished our tour of downtown Mantorville, leaving the cozy town with pleasant feelings and perfect pictures of a grand day permanently etched in our minds. Little did I know that it would be years before I returned to Mantorville. That's not to say that I wasn't thinking about the comfy, cozy little town. And like I said, perhaps it was thinking of me—a mutual engagement, one in which we could both be rewarded. I would spend time learning about the wonderful town and the people within, telling myths and legends about it. And the town lives on, deepening its history with new people and new stories, in a ghostly sort of way. A win-win situation if you ask me. So long as the ghosts don't revolt, not to mention the gypsies.

# HUNTING FOR HAUNTINGS

O ne thing led to another in my writing career, and I found myself authoring books about ghosts. No, not ghostwriting, as in writing for someone else. Instead, I bang on the keyboard for stories of the paranormal. Shortly after accepting the first contract to do the work, I thought to myself, "What in the world did I just sign up to do?" I didn't know anything about ghosts. Sure, I had pondered the idea of them when I was younger, but I had no time to think such silly thoughts as an adult. Or did I? Perhaps, like in my earlier trips to Mantorville, where it felt as if an invisible force had *lured* me there, that same energy funneled my writing endeavors toward the paranormal. Besides, you never turn down a writing assignment, right?

Like any good, desperate writer, I enthusiastically agreed to do the nonfiction project about the paranormal. I also, like a typical writer, delayed my research and writing until the last moment (procrastinators unite!). That isn't to say I didn't do a lot of thinking about the project. I mean, who *wouldn't* want to write about something as cool as ghosts? And not just any ghosts—*real* ones, from around where you live.

It turns out that there are a lot of stories out there about ghosts. In the process of collecting stories, driving all over the state of Minnesota to take pictures and interview the ones unfortunate (or fortunate?) enough to have been plagued by the spiritual entities, I found myself once again back in Mantorville. I must say, the stories I heard about the haunted Opera House were enough for an entire book. But then there are other haunted buildings in Mantorville, too, it seemed. I was hooked and had to come back.

One of the many gravestones in Mantorville's Evergreen Cemetery.

But wait a minute—I was no ghost hunter. How does this process work, of finding the spirit world? Thus began the research. First it started with watching numerous episodes of *Ghost Hunters* on the Syfy Channel. Then it was *Ghost Adventures* on the Travel Channel. I found myself thinking, "Could this ghost stuff be real?" It had to be, right? I mean, who would make this stuff up?

In order to answer my own questions, I decided to do some paranormal investigation. Armed with my digital recorder (affectionately named DARREN, which stands for Digital Audio Recorder of Really Eerie Noises) and a Sony night-vision camera, I set out searching for spirits in the night.

It didn't take me long before I realized that it's much more than just sitting there and recording the darkness around you. Actually, I didn't really understand paranormal investigations until I hooked up with a real team, the Twin Cities Paranormal Society (TCPS). And what better place to do an investigation than in Mantorville? As luck would have it (or perhaps it was destiny), TCPS was planning a trip to Mantorville in November 2007. My deadline for my first ghost book was the end of 2007, so why not involve a real investigation? I couldn't have been happier.

As I have mentioned, what you will find in this book is a compilation of my time searching for the truth about ghosts. Even after my first run-in with TCPS in Mantorville, and having a serious feeling that ghosts were definitely real, over the months I began to lose my concrete paranormal belief. I found myself once again questioning if ghosts were real. And there was only one way to find out for sure.

So when The History Press came to me and asked about writing more ghost stories, I immediately thought of Mantorville. I felt as if there was more to be said about the historic town in a ghostly sort of way. And along the path, perhaps I could write about my search for the truth of the paranormal. Of course, that's exactly what this book is about.

I must say first and foremost that Mantorville is a terrific town, full of wonderful, bright, cheerful people. Those living in the community willingly open their doors to all and are positive and eager to share their town with strangers. Still, with all of the ghost stories and tragedies to those living there, might there be something else going on? An ancient Native American curse? Some strange, demonic evil lurking beneath the ground? Something worthy of Stephen King?

I seriously doubt that there's anything that devilish brewing in Mantorville. It's such a nice town. Nothing bad ever happens here, right? Well, come along on my journey explaining the ghostly trials and tribulations of Mantorville.

Speculate with me on what's really happening in the tucked-away town. Terror? Mayhem? Possibly.

Keep in mind that the things we know and are familiar with in life are typically not scary. It's the unknown that we fear most. Fear of heights (which I believe is more about a fear of falling or, even better, a fear of hitting the ground at high velocity), fear of darkness, fear of monsters in the night—the list goes on. We fear that which we do not understand. So as you read through the different stories and myths of Mantorville, keep an eye out for the "what if" questions. Think through the speculations. Perhaps the plain and simple town of Mantorville is altogether something different—something out of this world and complex.

Regardless of your beliefs in what sort of town Mantorville is, I recommend you come and visit. Find out for yourself just how spooky the place really is. Take a tour of the haunted buildings (around Halloween is best) and see if you have a personal experience with a ghost. Better yet, perhaps an apparition will visit you as you walk across the stage in the Opera House or while you sit quietly in the jail of the basement in the Restoration House. Will you feel creepy or comfy? There really is only one way to find out. Come to Mantorville; the people are friendly and cheerful—or maybe that's just a coverup for something more dark and sinister.

Enough with the small talk. Let's get on with the topic of discovering the paranormal. First of all, I'd like to explain the techniques and mechanics of paranormal investigating. While I'm sure some reading this are well aware of what to do while hunting for the spirits, I'd like to make sure the less fortunate ones understand some of the terms and techniques explained in this book.

# EQUIPMENT

BAROMETER: For when you need to measure atmospheric pressures. Sudden drops and rises in the air pressure could be the result of a possible paranormal event. Or maybe it's just a storm coming through. Either way, you may want to take precautionary measures.

CAMERA: This is the "don't leave home without it" device. How could you possibly take yourself seriously as a ghost hunter if you don't bring a camera? There are lots of options: digital still, video, trail camera, infrared,

full-spectrum and so on. Nowadays you can get them with built-in digital memory, allowing you to download directly onto your computer later. Definitely saves the hassle of developing your own pictures or converting from tape to computer.

CELLPHONE: Mobile phone—need I say more? Who ya gonna call?

DIGITAL AUDIO RECORDER: This is one of my favorite devices next to the flashlight (for obvious reasons). I call my audio recorder DARREN. And believe you me, it has captured some really eerie noises befitting of its name. And that's not including the noises during a ghost hunt.

EMF DETECTOR / MEL METER: Contrary to popular belief, this is not an Elephant-Moose Finder. And no, it won't find you the perfect melon at your local grocery store (although I've never tried that). EMF stands for electromagnetic frequency. An EMF detector attempts to register changes in magnetic or electronic radiation near the device. This is a must for any serious paranormal investigator.

EXTRA BATTERIES: This is another obvious one. Why take the chance on an entity draining your existing batteries and miss that Class A EVP or the perfect full-body apparition picture? Bring extra batteries. It's a simple thing to do.

FIRST-AID KIT: This has to be available. It's not an option. And it's not just for when the ghost scratches your arm or rips your arm off entirely. It's more for when you trip over a chair or fall down the stairs in the darkness. Nothing like making the ghosts laugh—and you thought it was a haunting laugh.

FLASHLIGHTS: This is, of course, not for the benefit of the spirit world but rather for finding your way around in the dark. Headlamps work great, but you should still have a handheld, as you will find yourself pointing at things in the darkness. It's much better than jerking your head around.

INFRARED THERMAL SCANNER: This is a cool device to have. It will take video of temperature fluctuations. Be forewarned, however; they are very expensive, typically costing a good $3,000–$5,000. Ghost hunting is cool, but I could buy a few hundred horror movie DVDs for that price.

K2 METER: This is a simple device with several LED lights on it. Supposedly, when spirit energy comes close to it, the LEDs light up. It's basically the same as an EMF detector, only there is no signal level displayed, other than through the LEDs. It's nice to set down in a room and watch from a distance.

MOTION DETECTORS: These are great when dealing with prankster poltergeists or if some team member inadvertently walks into a secure location with cameras. I've used trail cameras with motion sensors—they are excellent for outdoor work or for long-term investigations.

NIGHT-VISION EQUIPMENT: It goes without saying that your camera equipment will need night vision if you are hunting ghosts in the dark (what other way is there?). And it doesn't hurt to have a monocular scope available, for your own viewing pleasure.

RADIO (AKA WALKIE-TALKIE): This has to be part of your investigation if you have more than one team working. It's critical to contact the other team when you suspect them of making a sound. Or you can use it to scream into when a demonic apparition is bearing down on you.

THERMOMETER: A handheld thermometer is important to have with you. It should be able to read the ambient temperature of the room. If possible, get one that can detect temperature fluctuations at a specific point in the room. This will help detect cold spots across the room.

# HAUNTINGS

The next subject to discuss deals with the different types of paranormal entities you may find. Sure, we could get into discussions about poltergeists, shadow creatures and full-body apparitions. But basically the paranormal world is broken down into two groups.

RESIDUAL HAUNTINGS: These types of hauntings are the most common. They typically occur when you have a spirit repeating itself, doing the same thing over and over again at different times of the day or week. There is no human interaction—it's like a movie being played back repeatedly.

INTELLIGENT HAUNTINGS: These are not as common but are much freakier. This is when you can communicate with a spirit. Typically done through a K2 meter or EMF meter or through an audio recorder (when played back later). This can also occur via poltergeist activity.

# EVIDENCE

Whether you find yourself confronted with residual or intelligent hauntings, your evidence may come in several forms.

EVPs (ELECTRONIC VOICE PHENOMENA): Essentially, anytime you capture a voice on electronic media that wasn't created by a known voice in the room, it is an EVP. There are different classifications of them:

- Class A: The best of the best when it comes to EVPs. The voice recorded is clear. You know exactly what was said and know that it didn't come from anyone on your team.
- Class B: Here the voice is somewhat muffled, making it difficult to verify what was being said. Still, it is clear that a voice was spoken and not from anyone in the room.
- Class C: These are the most common EVPs, ones that have little to no value in the paranormal world. They are voices you think were heard, and you have no idea what was said. It's hard to back up any claims with this type of EVP.

APPARITIONS: Apparitions are entities you see with your eyes or with video, moving around the room while you investigate. They can be quite clear or somewhat foggy, depending on the type.

- Mist/Shadow: These apparitions have little to no concrete definition to them. They seem to be more smoke or fog than anything. Yet you see something, more like a dark, shadowy figure.
- Full-bodied: It is pretty obvious what these apparitions are; when you run into one, you know what you're dealing with. And most people then run and scream in the opposite direction.

POLTERGEIST: These are hauntings that don't show up as sound (EVP) or apparition but rather are indirectly experienced through the movement of an object. Typically this is caught on video, with a chair moving across the floor all on its own.

# The Investigation

I'd like to take some time to explain what your typical paranormal investigation would be like. Of course, there's no such thing as a *typical* investigation—unless nothing happens at all. Any time you capture paranormal evidence, the evening is anything but normal (it's paranormal, of course). I want to focus on your typical ghost hunt. For those who have done paranormal investigations dozens of time, you can pass by this section (unless you crave nostalgic manna). But for those who have never searched for ghosts, and are interested, read on.

The beginning of your paranormal investigation should start days or weeks before the actual event. First of all, you have either contacted the owner of the building or he has contacted you. The next step is to interview him to find out more about the supernatural events occurring. This can easily be done over the phone. Then, in the event that you feel it's something important to investigate (or there are serious issues at hand—most importantly including frightened children), you set up a time to meet with the owner. Or, in some cases, you simply gather your team and schedule a night to show up.

Once you arrive, you check in with the owner and verify that this is a good night for them. If all goes well, next you should have a walk-through done with the lead investigators and the owner. Sometimes it helps to bring a third person along to take notes or to simply record what was discussed. This information will be invaluable later, when determining the location of cameras and your overall plan of attack.

Once the walk-through is complete, and you have planned where to investigate and where the cameras should go, you can begin setup. This typically takes anywhere from thirty minutes to an hour. It's good to keep an eye on the progress and make sure that equipment is fastened and positioned appropriately. The last thing you want is to have the owner kicking you out because you duct-taped a camera to an important painting or you fastened a helmet cam to the family pet.

Hopefully, if you arrived at about 8:00 or 9:00 p.m., you should be able to start investigating by 10:00 p.m. Depending on the size of your team, you may need to split into two or more groups. Having a group of no more than three or four investigators is ideal.

Start the investigation with ten minutes of silence, or as I like to call it, ten minutes of "ghostly quiet time." This is a critical step in the process and should not be skipped. The ten minutes is for both you and the paranormal

entities. It helps you and your team settle down and get into the supernatural mood. It also helps you adjust to the lights, sounds and overall environment. It's also good for the ghosts, as it allows them to acclimate to you as strangers in their world. Always remember—you are the guests in their domain.

Once the ten minutes of quiet time is complete, you can start talking with the spirits. It's best to first introduce your team to them, allowing them to know your names and maybe something about you. Then, after a brief pause, start asking questions. Typical questions include "What is your name?" or "Can you give us a sign of your presence?" or "Whats have I gots in my pocketses?" Okay, maybe the last question is not necessary, unless you're Bilbo Baggins.

The most important thing to remember when communicating with the paranormal is not to provoke them. That kind of makes sense, doesn't it? I mean, why would you want to make a ghost mad? Most importantly, you don't want to create a lasting anger, one that lingers long after you've left, leaving the owner to deal with the problem. No, the best thing to do is keep things positive. After all, you have to remember what your primary objective is in paranormal investigations (other than collecting evidence and trying not to have cardiac arrest): helping the spirits cross over into the other world.

As you are investigating, it's important to "tag" things that happen. In other words, you speak up about things that are happening to tag them on the audio recorder. For instance, if your stomach growls, you should mention that on the tape. Otherwise someone will hear it later on and declare your stomach and its lack of nourishment as a Class A EVP.

If you are split into teams, you typically do a single room or area in about an hour and then switch things up, rotating team members around. Also, if you discover a hot spot of activity, it's important in most cases to inform the other group. Sometimes, though, a group will remain silent, hoping that the new group replacing them in the location will find the same paranormal anomaly. That seriously helps in fortifying the evidence and authenticity.

Another thing to remember is to keep an eye on the video and audio recorders to ensure that they have enough tape or space on their digital cards. Many a time have investigations lost valuable evidence when a battery has run low due to spirits absorbing the energy in the room.

Lastly, always make safety number one on your list. When investigating, travel in pairs and don't leave anyone behind. After all, you don't want to become a ghost yourself!

At the end of the night, thank the owner for letting you in to investigate and give them a reasonable time as to when you will have results available.

Once the evidence is tallied, you can schedule a time to meet with them if the information gathered is serious in nature. If minimal evidence has been found, an e-mail or phone call is sufficient.

Hopefully this information helps you get a better idea as to what goes on during your typical paranormal investigation. These details are by no means all-inclusive, and there are other ways to orchestrate a ghost hunt—just so long as you keep things professional and safe.

# PUNCH DRUNK BREWERY RUINS

This chapter focuses on breweries and getting punch drunk. Okay, actually it has nothing to do with punch or drunk but everything to do with the old brewery ruins of Mantorville. The ruins are very cool—your classic crumbling-down building location. What's even more spectacular is that they are practically in downtown Mantorville. But are there ghosts there? What is the history there?

Back in the beginnings of Minnesota, the race for the best commercial beer was on. Beer was officially being brewed in Minnesota as early as 1849, with local lagers and ales being sold from Hamm's, Grain Belt and Schell's. Mantorville was no exception. If you're interested in finding out more about the history of Minnesota breweries, don't hesitate to check out *Land of Amber Waters* by Doug Hoverson. It's a great read and has even won the Minnesota Book Award.

As for the brewery in Mantorville, it began its days back in 1874, being built downtown just a block east from the Hubbell House. It was built by Charles Ginsberg (not to be confused with Charles Lindbergh, who also was from Minnesota) into a bluff of solid limestone on the edge of Dieter's Woods. It was made from the limestone quarried in the same location. Caves were dug to house more than seven thousand barrels of beer. A nearby spring brought water to the brewery, providing a crystal-clear taste to the barley brew.

The brewery eventually fell on hard times, in particular during the prohibition years of the early 1900s. It was difficult for any local brewery

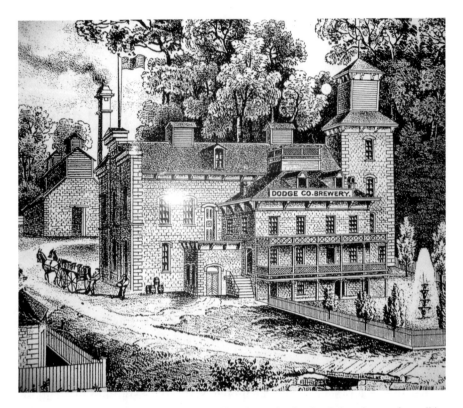

The Ginsberg brewery in its original form. The picture is of a sketch hanging on the wall in the old log cabin. Artist is unknown.

to survive then, for obvious reasons. It's never a good business plan to make a product that you can't sell legally. Of course, that didn't stop some from brewing beer illegally, becoming bootleggers and selling in private. Eventually, however, the Mantorville brewery closed its doors in the early 1900s, and the metal and equipment were sold off during World War II for wartime use. The products of the brewery, such as Otto's Lager and Mann's Beer, would be no more.

While there were several owners of the brewery, the most notable was Charles Ginsberg. He was born in 1831, was of German decent and lived in Dodge County for twenty-three years. Sadly, he took his own life on April 24, 1878, at the age of forty-seven, by drowning in the nearby river—the very same water source used to supply his brewery. To this day, it is not known why he took his own life. Could it be that Mr. Ginsberg was the victim of something paranormal going on? Might this

be one more artifact alluding to something more sinister going on in the town of Mantorville?

Near the brewery, a local Native American legend could be found in the famous Indian Chair. Apparently, the area was known to have been a meeting spot for the Native American tribes from the area or those traveling through. As legend had it, a great chair made from wood of a nearby tree provided perfect seating for the chiefs of the tribes.

After the Native Americans were forced out of the area, the chair and surrounding area became more of a playground for the children of the newly formed Mantorville. The children would climb up into this chair, which stood next to a dirt mound, supposedly an ancient burial mound of Native Americans. Could this area have contributed to the demise of the nearby brewery? What were the real reasons for it closing its doors and the owner taking his life?

In my research, I drove over to the location of the Indian Chair. While I could not find any sign of a chair, or burial grounds, it certainly felt eerie driving down a deserted one-lane road, only to find a dead end. Not feeling the most welcome, I promptly turned around and left the area, unable to do any significant investigation. Perhaps this is something for a paranormal investigation team at a later date.

As you might have guessed, the brewery currently stands in ruins, with only some of the caves visible and partially intact. The area around the ruins has become overgrown with foliage of buckthorn and trees, making it nearly impossible to see during the summertime. Thankfully, I arrived to check things out in the late fall, with all vegetation gone. So with all the rich history stemming from the Ginsberg brewery in Mantorville, and with its associated tragedy, it would be an easy conclusion that ghosts traveled among the ruins, right? Well, there was only one way to find out.

In terms of known ghost stories among the brewery ruins, there is nothing in detail to report. Hate to burst your paranormal bubble, but for the most part the list of ghostly legends around Mantorville didn't include the brewery ruins. That's not to say there aren't any ghosts there—all you need is some willing and able ghost enthusiast to embark on an investigation. And that person would be me, as you've probably guessed.

Keep in mind, however, that there *are* stories of interesting things happening at the brewery ruins. Local residents claim to hear strange sounds coming from within the building ruins late past the witching hour—howling and moaning from somewhere within the shredded walls and rubble. Perhaps the sounds are the hauntings of past employees, toiling over a new batch of brew

or rolling phantom barrels of beer across the limestone floor. Some say that if you stand quietly near the ruins you can still hear them making beer today.

Lights have also been seen emanating from the ruins. Small, fast-moving balls of white light traveling in a determined motion fly from the basement area out into the night. They have apparently been seen by those passing by in cars or by patrons leaving the Hubbell House late at night after enjoying an excellent dinner and cocktails.

Like any good person with an inquisitive mind, I decided to find out for myself if any of these stories were true. I took a trip to Mantorville not only to take a few pictures of the buildings around town for this ghost book but also to investigate the old brewery ruins. For anyone who's ever tried to hunt ghosts in a mostly torn-down building, with most of the outside elements interfering with you, well, it's pretty much a crapshoot on whether you'll get decent data. But I had to try anyway. Anything for a story, right?

For me, it wasn't about the concrete evidence while traversing among the limestone foundation walls. I wanted to at least get some type of personal experience or maybe get lucky and snap a picture of some ectoplasm. That

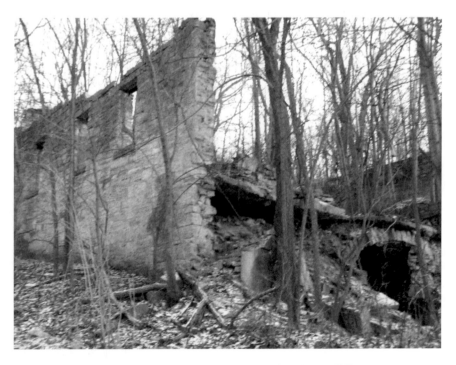

Not much is left of the Ginsberg brewery. But perhaps a few ghosts still linger.

could propagate additional investigations, with the proper approval of the building's current owner. With my camera in one hand and my digital audio recorder (DARREN) in my other, I journeyed into the ruins of a once prosperous beverage manufacturing plant. I was excited about what I might find.

It didn't take long for me to realize that something interesting was going on. The sun had just set, sending faint but long shadows across the trees as I entered the ruins. I paused a moment and realized just how quiet things had become—eerily quiet. There's a fairly close road just to the left of the brewery ruins, as well as a running creek in front. The Hubbell House is no more than a block away. You would have thought that there would be lots of noises, but no—everything seemed muffled for a moment, like I had entered some alternate dimension where sound was not an element readily available.

Time also seemed to slow down during my moment of solitude. It definitely felt surreal, like at any moment the landscape would start to melt off the canvas I was viewing, like in Salvador Dali's painting *The Persistence of Memory*. Okay, maybe it wasn't that extreme, but I seriously felt like I was briefly in another dimension, void of sound, time and maybe even space.

The experience only lasted a moment, and soon enough the sound of cars, babbling creek and busy people in the distance returned. The feeling, however, remained within me, putting me in a spooky, tingly mood as I entered the first section of the ruins.

Might I remind you that ghost hunting by itself is foolish to do alone. Crawling around in a crumbling building is beyond stupid. Regardless, I carefully trudged on into the darkness, hoping that I wouldn't get attacked by any ghosts or have a wall of the cave fall in on me.

Still, I wasn't a complete ignoramus. I did have a float plan. What's a float plan, you ask? It's something you put together to explain where you are going, when you are going and when you are expected to be back. In my case, it was more of a "ghost plan." I gave all of the pertinent information on my whereabouts to my wife, with clear instructions to come look for me if I wasn't back at a suitable time.

At any rate, I found myself standing alone in the darkness of the brewery ruins' basement, asking for the spirits around to show themselves. With my audio recorder in hand, I asked all the classic questions, I introduced myself (I always hate to be rude to ghosts, especially since I'll be one someday, I'm sure) and I took lots of pictures.

Of the dozens of pictures I took, a couple did stand out as interesting. A picture here shows a hazy figure of some sort in the center. At the time, I

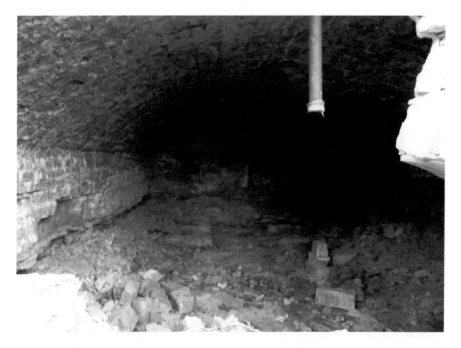

One of the Ginsberg brewery caves in the basement, showing a gray mist forming in the center.

do not recall seeing anything. But the photo clearly shows that something is there. Perhaps it's the ectoplasm of a ghost slipping into this world.

As most paranormal investigators know, much of the ghostly evidence one finds during an investigation comes after everyone is gone and the equipment put away. It isn't until later when one goes through the volumes of pictures, video and audio evidence that some real gems appear. In the case of the picture here, I would say that it's quite possibly of paranormal origin. Then again, being that I was partially outside (some of the ruins extend into the open, of course) and snow had begun to fall, it's certainly possible that the lens on my camera had gotten smudged. However, no other photos had this anomaly.

Another picture here is your typical, run-of-the-mill orb photo—lots of little dots, supposedly each containing the energy of dead people. It's exciting when these pictures show up, tantalizing your paranormal-seeking taste buds for the possibility of finding that ultimate ghost photo. Orbs are by far the most common paranormal evidence discovered while investigating. Along with that, they are also the most debated.

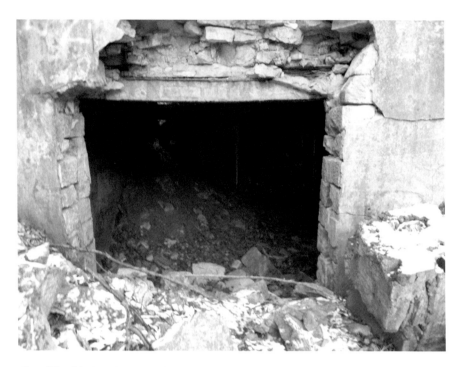

*Above*: The Ginsberg brewery, with another mist appearing. This photo is one of only two in which mist shows up.

*Below*: A classic orb projection in the basement ruins of the brewery.

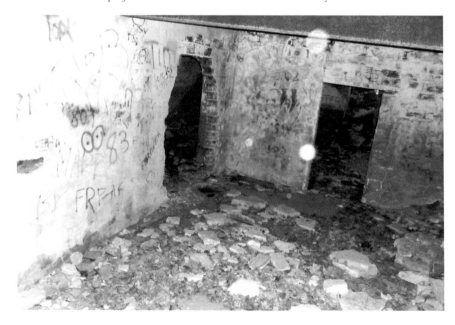

In my opinion, the phantom balls of energy are just dust particles near the camera lens as the photo is shot. I would have to say that 99 percent of the orb photos documented have nothing to do with the paranormal—more like the dusty-normal if you ask me. Flying insects can be the answer to the orbs found on video as well. The tiny creatures, when flying near the camera, can appear to be farther away in the room when, in fact, they are right in front of the camera. Little balls of energy seem to appear out of nowhere and then dart off in some random direction before disappearing altogether.

Regardless of your take on orbs, I believe that the potential for orbs does exist. It's just that taking still photos of them is, in most cases, pointless. For a real orb to exist, a large amount of energy would most likely emanate, morphing and changing position. Taking a single picture isn't going to prove much of anything for a dynamic ball of energy like that. Video cameras are much better for providing genuine evidence of orbs. Even then, you must deal with the dust particles or flying insects veering into view and then darting away.

While visiting the ruins, I did not capture any flying orbs—just the one picture of potential orbs. Other than the creepy feeling I had when I initially stepped into the ruins, the remainder of the investigation was calm and uneventful—well, except for the demonic troll that jumped out of the wall near me. Just kidding; wanted to make sure you weren't falling asleep. Still, I did have a small rock or pebble get tossed at me. It freaked me out initially. But it could easily have been a crumbling rock falling from the ceiling. Once again, no perfect evidence for me.

The audiotape from my digital audio recorder DARREN had a few things of interest. At thirteen minutes, two seconds, a strange blip occurred, like an unexplained energy surge. Shortly afterward, the sound of a rock or pebble being thrown is heard.

Later on, a strange noise is heard, like a yelping sound, just after I ask, "Give me a sign of your presence." A few minutes later, a definite voice can be heard, coming just a few feet from me, even though nobody was around. It was as if someone was talking to me for several seconds. Then the voice vanished.

One major note to mention is that the investigation I performed both was executed only by myself and was outside. Both have issues with providing valid evidence. In the end, if it is only you investigating, you will typically only find personal experiences. But it's also very dangerous—not only for the possible ghost attacks but also if you were to fall or get trapped. Always travel in pairs. The buddy system is best.

Most importantly, the evidence I collected could easily have been false information, based on it being outside. It's amazing how far sound travels sometimes. For all I know the voices I captured could have been from someone walking out of the Hubbell House blocks away. Still, it's important to note the possible evidence, for you never know if it is real or not. I find it all too easy to cast away strange voices, or thumps in the night, as logical explanations. Keep an open mind and try hard to discover the real truth.

So are the brewery ruins haunted? It's inconclusive, certainly. Based on the lack of evidence, I cannot say that it has any ghosts making noises or flashing orbs flying about. I did get the interesting picture with the potential phantom ghost appearing. So maybe it's haunted and maybe it's not. Why not find out for yourself? Just make sure that you have permission from the owner. Otherwise you will be trespassing, and I'm told that both the owner and the ghosts don't like that.

# RIVERSIDE GIFTS FROM BEYOND

When I first heard about the hauntings at Riverside Gifts, a store filled to the brim with wonderful knickknacks and keepsakes, I shrugged them off as just some crazy stories from even crazier people. But I've known the owners for several years, and I know they're not ones to make stuff up. They're not trying to drum up business, attempting to add to the already spooked town. I know the stories have to be real because they came from real, honest people.

The Hoaglunds have owned Riverside Gifts for a number of years and are quite comfortable with its surroundings, both normal and paranormal. The building itself was built back in 1856, a few years before Minnesota became a state. The building was originally known as Riverside Mercantile, containing just about everything one would need back in the mid-1850s. The name remained for a number of years, but when the store eventually changed owners, it became Gas Lantern Antiques.

From there, it was the Edmund Beatty Furniture store and, my personal favorite, the Edna Britts Furniture and Funeral Parlor. I don't know about you, but I'm thinking it must have been quite convenient to make furniture and support the funeral business. I bet the furniture store built a terrific casket. Or would that be a horrific casket?

By the 1970s, the building had changed hands once again, to the Hunts, and the name was changed to Suzy's Shoppe and Gallery. It became one of the focal points of the town. Suzy and Tom Hunt spent many years in Mantorville, working hard at building the town back up after it had decayed

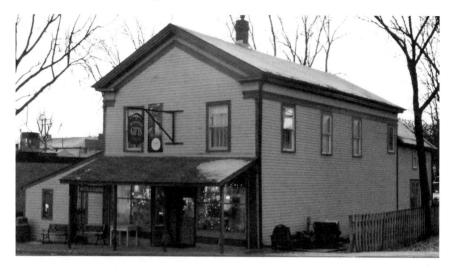

The front of Riverside Gifts; the back of store houses an old funeral parlor.

over the past decades. With their help, Mantorville was back on track, with the entire town even becoming a national historic landmark. The Hunts even brought in a historic log cabin, situated just behind the gift shop. Makes you wonder what Peter and Riley Mantor (the founders) would be thinking about their great town.

Suzy and Tom Hunt ultimately moved away, leaving the building vacant. But not for long. The Hoaglunds decided to purchase the property, and so began the Riverside Gifts business.

One of the main stories told about the hauntings of Riverside Gifts stems from the back corner room. As with any unusual and paranormal experience, the room has a dark past. In the earlier years of Mantorville, the room in the back of Riverside Gifts was used as a funeral parlor. Many dead folks have traveled through the back of Riverside Gifts, which would explain some of the ghostly experiences going on.

In general, many of those visiting the store have mentioned a dreadful feeling coming from the back room, as if something bad had happened there or someone was watching them from behind. Still others claim to have had something touch their legs, like a little child has just run past. Yet when they turn to look around, nobody is nearby.

Cold spots have also been reported, as if a chilling spirit had just invaded the area. This can occur in the middle of a hot summer day. But as quickly as the frigid ghost appears, it disappears all the same, leaving you wondering what had just happened.

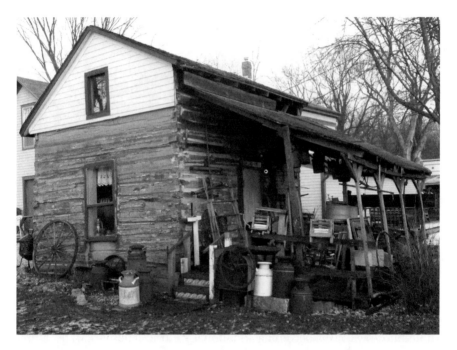

The log cabin behind Riverside Gifts, one of many historic buildings in Mantorville with reported ghost inhabitants.

The most notable activity occurring at Riverside Gifts involves the marble incident. No, it has nothing to do with playing marbles, although it appears as though that's what the ghosts may have been doing one afternoon. "All of a sudden," said a Riverside Gifts employee who witnessed the event, "there were marbles everywhere."

The afternoon seemed like any other in the shop, with patrons meandering through the intricate pathways around the multitude of sale items. But back in the corner (in the old funeral parlor area), with nobody nearby, a crashing and clinking sound of epic proportion was heard. One would have thought a rumbling earthquake had hit (which does happen from time to time in Minnesota, believe it or not), uplifting a jar of glass marbles and heaving them onto the floor. Marbles rolled to every corner of the store it seemed, leaving everyone wondering what had just happened.

Those who knew about Riverside Gifts' dark past knew what had probably caused the incident: ghosts. Why wouldn't they? With all of the hundreds of dead people shuffled through the doors of the now defunct funeral parlor, who's to say there aren't a few still lingering around?

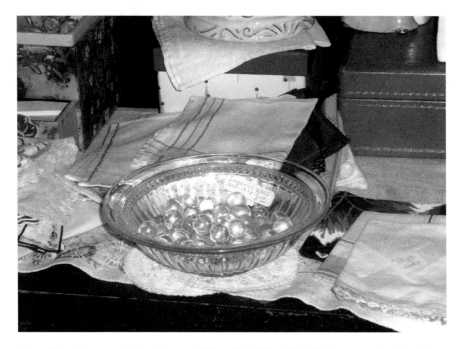

A jar of marbles near the back room of Riverside Gifts, with which a reported poltergeist incident occurred.

Enter Twin Cities Paranormal Society. Having been on some investigations with TCPS members before, I knew that they were the ones to call for help. If you're serious about your ghost hunting, call the professionals. Thankfully, TCPS was available to check things out. In fact, we were able to investigate several buildings in Mantorville over the course of several weeks.

The TCPS team is no stranger to Mantorville, and for good reason. In my mind, Mantorville is probably the most haunted town in Minnesota. I'm sure big cities like Rochester, Minneapolis or historic St. Paul have many more stories to tell. But with Mantorville having a population of fewer than 1,200, it could very well be the most haunted town around—per capita, that is.

As I was saying, TCPS is no stranger to Mantorville. The team has been investigating the ghostly hot spot since 2007. Numerous buildings have been visited, with countless bits of evidence proving in many eyes that Mantorville has several ghosts lurking around town. By reading this book, you will get to experience the investigations that TCPS performed, along with my experiences as well. Hopefully you will get a better idea of what goes on during your typical paranormal investigation.

As for Riverside Gifts, I luckily found a time that worked for TCPS to investigate there. Unfortunately, it was January. Sure, I know—why on earth would you hunt for ghosts in January? Well, why not? Perhaps all of the paranormal spirits are indoors, too, waiting for the spring thaw? Maybe that's when most of the ghosts show up? I was eager to find out.

At about 9:00 p.m. on a Friday night, TCPS joined me at Riverside Gifts. The air was electrified with energy; the thrilling possibilities of finding the elusive but perfect paranormal evidence loomed over us. Could this be the night that we get that full-body apparition, complete with splattering ectoplasm? Or maybe a few Class A EVPs? There was only one way to find out. Jumping headfirst into the bleak darkness of an empty ancient building couldn't have been a more perfect situation. Especially with the proverbial funeral parlor of yesteryear in the forefront of our minds.

As expected, we hit the old funeral parlor immediately. While TCPS has a multitude of paranormal investigating equipment, the members decided to go light and used only a handful, such as the classic EMF meter, video camera, digital still camera and several audio recorders. They also set out

The back room of Riverside Gifts, which used to be Mantorville's funeral parlor.

a seismic detection device. It's typically called a geophone and is used to detect slight vibrations in the area around it. This can help when there are reports of footsteps through the area. In our case, we hoped that it would help with the marble incident, seeing if there were any vibration issues causing the marbles to roll out of the dish. If any of these episodes occurred, we could catch the movement via the geophone. I wondered if I could use it to call home.

The first phase in paranormal investigations, according to TCPS (as well as other groups that I've talked with), is to interview the owners and do a quick tour of the location. We did this with the lights on, of course, which is a good idea, in order to get your bearings on where you will be walking later while in the dark.

Riverside Gifts is composed of a basement, a main floor and a second floor. While I was interested in checking out the basement—always a favorite of mine, ever since my spooky issues in the basement of my old farmhouse growing up, but that's another story—the owner indicated that it might not be the best to go down there, what with all sorts of storage items and things that would get in the way. Or perhaps she was covering up a darker past? Something more sinister lurking in the basement shadows? Doubtful. Theresa hasn't a deceptive bone in her body. I'm sure there's no dark, evil spirits lurking beneath the floorboards of Riverside Gifts. But perhaps that will have to wait for an investigation at a later time.

The second floor was still set up as a photography studio, wide open and with plenty of room to walk. There were no stories of ghosts up there, but since we were available, it wouldn't hurt to check it out. Once the tour of the area was finished, it was lights out for us and time to search for the paranormal.

The second phase in any serious ghost hunting is spending a few minutes of silence. TCPS likes to do ten minutes. This "time out" is good for both the ghosts and investigators. For the spirits, it gives them some time to acclimate to us, these strange people tromping around in the dark late at night. After all, I'm sure that doesn't happen too often for a ghost. Kind of scary for them if you ask me—that is, if a ghost can get scared. Believe it or not, I think that's entirely possible.

The quiet time is also good for the investigators as well. It allows you time to relax and get into the investigative mode, to try to settle down and open yourself up to their existence. Some say that if you walk into an investigation as a nonbeliever, you will most likely walk out one. "Ask and ye shall receive" is a good proverb to follow while looking for ghosts. I'm

not saying that this is always the case, but it doesn't hurt. Sure, it's good to walk in as a skeptic, but your energy, or your aura as it is sometimes known, may intimidate the spirits around you, making them shy away and not be as easily noticed. Even as a skeptic, you should at least be open to the possibility of spirits—of an afterlife intermingling with us living folks. Besides, what's the worst that can happen?

So the ten minutes of silence has begun. Your first feeling is to scream, because all of the lights are off and you're sitting in a pitch-black room, waiting for ghosts to appear. How crazy is that? I mean, really, if you are truly a believer, you must be freaking crazy to dance with the afterlife and be willing to visit with energy beyond our realm of comprehension. Of course, if you're a nonbeliever, well, you're still kind of crazy just to be there. I mean, what's the point for you? Although, I'll say it again: what's the worst that can happen?

There are those who are convinced that ghosts exist. They have found concrete and intimate proof that makes it real to them. They are hunting ghosts for an additional high. Like a taste of the infinite nirvana, they want more. They want better answers and more proof for the world so people will undeniably know that they are not crazy.

Then there are those on the fence. The ones who think that they might believe and have seen something strange in their lives but can't quite explain it. They spend their lives wondering if perhaps ghosts are real and have an appetite for the truth. They want to know for sure and are willing in many cases to explore the possibility of the impossible.

Finally there are those who are coldblooded skeptics. They've never seen a ghost or anything paranormal or strange. Even if they did, they can explain it off in several rational ways that give them comfort, allowing them to safely sleep at night. They are out on investigations to disprove things. They are the ones difficult to convince. They will most likely never believe in the paranormal, unless the ghost of their grandmother visits them directly and tweaks them on their ear.

As for me, I'm still somewhere in between. I've had strange experiences, seen shadow figures and experienced poltergeist incidents, but somehow I'm not an absolute believer. Perhaps the scientist in me still screams foul play. How can you believe in something that you can't see, feel or touch? Of course, all of these things happen, but at a personal level. This means that it's hard to explain and prove to the rest of the world what you've experienced.

The ten minutes of silence has come and gone, with no shrieking and wailing from the ghosts (or us investigators), and it is time to find some paranormal evidence. Questions begin to be asked of the spirits: What is your name? Did you work here? Do you know what year it is? The list goes on. Basically, you're trying to make the spirits comfortable. Given that you can't reach out and shake their hands or offer them a drink, talking to them is about the only way to loosen them up.

It's rare that the ghosts would answer your questions live; most of the time their responses come later while reviewing the audiotapes. Here's a list of notable events I captured while at Riverside Gifts that night.

Just a few minutes into the investigation, one of the TCPS team members mentioned how heavy the air felt as we sat in the funeral parlor area. I didn't want to mention anything at the moment, but I had the same feeling. It wasn't really negative, more like an extreme pressure being placed on us from every direction, sort of like the air was being squeezed out of the room.

TCPS members placed their geophone on the ground in the center of the old funeral parlor, detecting any subtle vibrations nearby. The device never went off by itself, but it's hard to say if that indicates that the place isn't haunted. Also, voices could be heard from time to time during the investigation. It is possible, however, that the sounds were coming from the other team upstairs (we had split into two groups). We discussed this with the other team and could not identify if, in fact, it was them talking.

The only EVP that we caught that seemed definitely paranormal occurred in the old funeral parlor area. Will from TCPS asked the spirits if they were familiar with the Hubbell House. Immediately following the question, an eerie, whispering voice is heard saying, "Get…out." Now I don't know about you, but that brings back memories of watching *The Amityville Horror.* And it's sort of an unspoken rule that when supernatural entities tell you to get out, you do. Unfortunately, we did not hear the voice at the time, only afterward upon reviewing the audiotapes. Thankfully, the ghosts didn't seem to mind that we weren't listening very well.

After spending quite some time on the main floor in the old funeral parlor area, we headed upstairs to investigate. I must say that it was a peculiar feeling, sitting in an old funeral parlor and wondering where the dead bodies were stored (basement perhaps—maybe they're still there), where the embalming took place or where forensics may have been performed. Perhaps I was sitting right where the bodies were embalmed, analyzed and poked at before they went their way to the grave. There were a few times I

felt like someone else was there with us, but I couldn't pinpoint it. Maybe there was a room full of ghosts, stuck in limbo at the funeral parlor and still waiting to cross over.

The upstairs was uneventful and quite peaceful actually—no feelings of dread, no apparitions, no nothing. That's the thing about paranormal investigations; you can usually feel the presence of something paranormal going on. The hairs stand up on your neck, a heaviness in the air arrives or you feel a sickness in your stomach. But none of that was happening on the second floor.

As far as videotape evidence, sadly, there was none. Apparently there was no answer on the geophone. Either that or we dialed the wrong number.

So in the end, I would say that it's hard to state that Riverside Gifts is haunted. There was no permanent, tangible evidence—only personal ones. Then again, perhaps there need to be a few more investigations. Ghosts don't show up on cue. Maybe it was their night off, or maybe we offended them. Regardless, it was an enjoyable time sleuthing for spirits at Riverside Gifts.

# SPIRITS FROM THE SEMINARY RUINS

I was dying to find out about the Seminary Ruins, which is never a good thing when ghost hunting. The last thing I wanted was to become one of the hunted. Still, it excited me to find out about the ancient ruins close by.

No, the Seminary Ruins are not within the city limits of Mantorville. They're actually a couple miles northwest, in the small town of Wasioja. And with the rich history covering the site, it had to be one of my stops for the search of the paranormal. There had to be ghosts there. The question was, then, could I *find* them?

The only trouble was that I hadn't heard much of anything about hauntings at the location. Sure, there are the typical spooky sounds in the middle of the night that neighbors hear, as well as strange lights that are sometimes seen in the area. It was also a hot spot for teenagers daring others to spend a night in the ruins, waiting for the paranormal to appear and seeing if they could survive the night.

Regardless of the number of stories, I felt that it was important to find out for myself. After all, maybe it's a location that is seriously haunted but nobody has taken the time to check it out. Like I have indicated, there's a lot of history with the place—a perfect spot for the spirits to dwell. So, armed with my audio recorder DARREN and his best friend, Mr. Cam Corder, I set out for a hopefully haunting expedition.

Before I get into all of the interesting details of my search, perhaps I should set the basis for this adventure, detailing the ancient history of the place. Okay, it's not all that ancient, being more than 150 years old. Still, in a

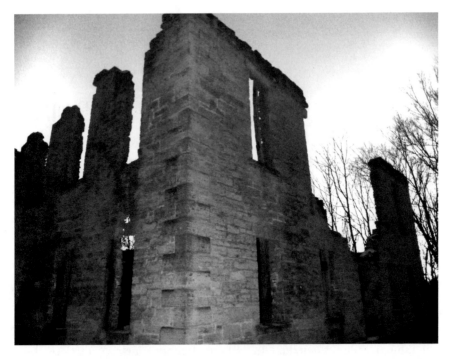

Remnants of the 1800s seminary and Civil War recruiting station. Now only ghosts remain.

Minnesota frame of mind, it's old enough. Any building older than our state constitutes ancient. Minnesota ancient perhaps?

At one point, the town of Wasioja had a multitude of community buildings. Nowadays it's just a spot on the map, a blink of the eye as you pass through. But 150 years ago, it was a thriving community. In particular, it housed a seminary, a college and a Civil War recruiting station. All of these were located in the same building—what is now known as the Seminary Ruins.

The Civil War recruiting station is the only Minnesota station to survive. It started, however, as a seminary. The Free Will Baptists, in conjunction with the people of Wasioja, built the native limestone structure in 1860. The seminary was opened in November that year with three hundred students. By 1861, the seminary/school had been renamed to Northwestern College, offering classes to all levels of primary and collegiate students.

By 1862, Wasioja was a bustling town. It housed a dozen stores, a hotel, a flour mill and countless farms, promising a solid future for the area. Unfortunately, the Civil War cut this progress short. Captain James George of the Mexican-American War asked the students of the seminary to join

up against the Confederacy. Professor Cilley led the young men to Captain George's law office and enlisted them. From that moment, Company C of the Second Minnesota marched off to war.

Snodgrass Hill near Chickamauga proved to be a battle with a very high cost. Out of the eighty who left for war from the seminary and surrounding area of Wasioja, only twenty-five returned. With such a tremendous loss, the bustling town of Wasioja never recovered. Most likely, those who lost their lives in battle might have returned in spirit form. Perhaps the Seminary Ruins are haunted by the ghosts of the Civil War.

The seminary tried to continue its school, and it eventually changed hands in 1868, reopening as the Groveland Seminary. The doors remained open until 1872. In 1875, it was renamed the Wesleyan Methodist Conference. That closed in 1894, and in 1905 a mysterious fire destroyed the building, leaving it as the ruins that you see standing today.

In the years following the war, the Civil War recruiting station was used as a law office for Colonel James George, as well as a jail, a storeroom, a post office and a private residence. Given all of these things, along with the age of the ruins, it is a serious possibility that the place might be haunted.

As for the paranormal investigation, I have to say that it felt very odd walking around the Seminary Ruins in the dark. Spooky indeed. I couldn't help but think about the thousands of people who had walked through the doors, some never returning, like the Civil War soldiers. Or did they? Perhaps they are the ones haunting the place, lurking behind your back and tapping it now and then, wanting to know about who won the war.

Or perhaps there are seminarians remaining, wanting one last lecture or stuck in this world, angered by the grades they received. After all, as seminarians, they are that much closer to understanding God, right? Who's to say that their energy and spirit isn't more intense, more reachable for the paranormal investigator—albeit more positive and subdued, we hope.

The ruins have certainly seen better days. That's why they call them ruins. And honestly, there isn't much left of the tall, two-story limestone building that once held court for so many men wanting to do their duty to God, or to our young country, back in the 1860s. The wooden roof and shingles had crumbled away long ago, as had all the windows. The second floor followed the same fate, due to the fire in the early 1900s. What's left is simply limestone walls, barren windows and open doorways. Then again, in some cases the limestone is all you need to find a few good ghosts.

These limestone walls certainly sparked my interest. Why, you ask? Limestone and quartz tend to hold energy in them. Quartz, in particular, is used as the original amplifier. Energy is easily trapped in the quartz and limestone, so in theory the energy of a spirit could more easily be contained within the walls. As the saying goes, "The walls have ears." In the case of ghosts, it could seriously be true. And they also have voices.

In most cases, limestone buildings contain residual hauntings—the kind that repeat themselves over and over again. Essentially, the limestone walls provide the perfect storage of these spiritual energies. As you walk by with your own energy, the energy in the wall can be triggered, once again sending the scene out into the nearby room, projected like an old-time movie.

For my ghost hunting of the seminary ruins, I would be investigating alone. And once again, I will reiterate to not do this. I am a professional at this. Okay, so maybe I'm not a seasoned veteran of the paranormal world. Still, I've done enough of this to hopefully survive. But if you venture out into the darkness alone, you do so at your own risk. It's enough to say that the last thing you want to do is meet a ghost face to face by yourself. After all, who would believe you then? More importantly, who would rescue you as you scream in a little girlie voice that you haven't used since the age of two.

As I traversed through the ruins, with DARREN in one hand and Mr. Cam Corder in the other, I asked lots of polite ghost questions and eagerly waited for their responses. It's always a good idea not to make anything paranormal mad. Chances are they can do some nasty things to you in the heat of the moment or later on when you get home. Yes, I've heard of several investigators who've reported spirits following them home. I'm not sure if the ghosts hopped a ride with them, took a cab or just phantom thumbed it. Regardless, I'd rather not have a full-body apparition floating above my bed in the dead of night, playing twenty questions with me as to why I had visited it earlier in the evening. So there I was, standing in the middle of nowhere, talking to ghosts and waiting for replies.

As I pondered why in Zeus's name I was out in the frigid November Minnesota weather, I heard something in the distance (in the dark of course). It sounded like footsteps. Or maybe just leaves rustling. I peered into the darkness but could see nothing. This, of course, is what you would expect when looking into darkness.

Now, when you hear unexplained footsteps in the darkness, most people run the opposite way (except in those horror movies, where the guy just stands there until the monster jumps out at him). Not me. No, I came here for

Another view looking into the Seminary Ruins. Some EVPs were captured shortly after taking this picture.

answers. I ran *toward* the sound. Well, there was a slight hesitation. After all, what if it's some demonic creature luring me in to drag me into the nearby ravine and devour me whole? Yes, much of my inner being was hoping that it was nothing at all. To this day, I don't know what I'd do if I actually ran into something like that library ghost in the opening of *Ghostbusters*. It makes me want to pack my own personal defibrillator—although I'm told it's difficult to defibrillate yourself.

Unfortunately (or fortunately, depending on your frame of mind), there was nothing in the vicinity. I wandered around for a while longer, looking beyond the safety of my headlamp, but could find nada. Zilch. I did the next daring thing and turned off my headlamp. There, in the mostly pitch-black night (there was still a full moon out, though), I found…double-zilch. That's not to say that I didn't have the hair on the back of my head standing up (and there's a lot there, mind you). I had that "there is something here" feeling, like at any moment an apparition would jump out at me. But no concrete evidence appeared—just more personal experiences.

Now for the fun stuff. Sure, I got nothing while standing there in the cold at the moment, but after reviewing the evidence DARREN had captured, I found a few potential EVPs.

At twenty-nine minutes, nine seconds on tape no. 11, I heard what seems like "No," after I asked, "Did you die here?" This immediately led me to believe that I may have contacted a Civil War vet who had died not in the area but in the war—perhaps in the historic Battle of Chickamauga. Somehow the phantom war veteran must have decided to come back to Wasioja, to his hometown area—a place that must have comforted him—and is still very much interested in living among us. I'm sure he felt comfortable, knowing that his side won the war. I only hope that he knows that. Or maybe that's why he's still around—he's still waiting for the answer about who won.

At forty-three minutes, three seconds, a strange noise was captured, sort of like a car driving by. But no cars (to my recollection) had driven by during the entire time I was there (the area is quite remote). Of course, if the ghostly sound was emanating from the past, I wouldn't think that there would be any sound remotely similar to a car engine. It's quite possible that the noise came from an airplane overhead, but I don't recall that happening at the time, either.

At one minute, fifty-five seconds on my next tape, a strong wind blew by (it was relatively calm that night), after I asked, "Give us a sign of your presence." Also, thumping from somewhere in the forest to the right of me

could be heard. Possibly Native American drums, or maybe Civil War vets drumming their cadence as they marched home from battle?

At two minutes, fifty-two seconds, I believe I captured the most convincing evidence. After I asked, "Show yourself," it sounds like I have a phantom response of, "Come again?" Perhaps the spirit didn't understand my question, as if it were quite obvious to him that he was right in front of me. Most interesting to me was that I comment a few seconds later that I thought I heard a voice. Spooky indeed.

In the end, I don't believe that I have any major evidence that would conclude that the Seminary Ruins are haunted. I would leave this location as plausible, as I had some personal experiences. I would encourage a team of investigators to do a thorough check of the area for any paranormal evidence, provided that it has adequate clearance from the current owner. If enough teams investigate the location, perhaps more details will be unraveled of the spirit world. Wouldn't that be spooktacular?

# RESTORATION HOUSE HAUNTINGS

When I heard about the Restoration House, my first question was, "What's a Restoration House?" Well, as it turns out, it's just that—a house that has been restored. Actually, it's more than that. Inside there are countless artifacts, a veritable treasure-trove of things from Mantorville's past. It certainly could be considered a museum as well. Of course, I was more concerned about the dolls and mannequins located in various rooms of the building. They gave me serious creeps, and I had no desire to be prancing around in the dark with them lurking about. But I guess that sometimes goes with the paranormal territory.

Located just off Main Street (Highway 57), up from the historic Hubbell House, the two-story Greek Revival wooden structure stands pretty much as fresh as it did when it was first raised. The land was purchased by Mr. and Mrs. Herman from the U.S. government back in July 13, 1859, one year after Minnesota became a state. The Restoration House served as the first courthouse in the county, as well as the county offices and jail, which is still located in the basement and is the only jail ever built in Dodge County.

Other owners included Jessie Hooker, Jay Tresdell, I.A. Norton, Orlando Campbell, A.A. Ware, Moses Kimball and Arthur Kimball. Eventually, in 1963, the building and property were purchased by the Mantorville Restoration Association for $1,700. Today it stands as a museum for all to learn about the history of Mantorville and give a taste of what life was like back in the late 1800s and early 1900s.

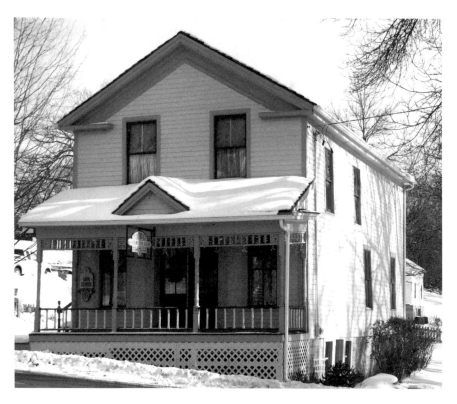

A front view of the Restoration House, which reportedly is haunted by a ghost or two and also has the town's only jail.

But enough of the walk down history lane. We're more interested in ghosts, right? Well, the Restoration House is no stranger to them. All you need to do is spend some time in the old building, and you'll know why.

It's reported by those working there (tour guides in particular) that someone of a phantom nature apparently still lives in the house. Late at night, footsteps can be heard upstairs, like children running around playing hide-and-seek. When an employee goes up to the second floor, nobody can be found. This has happened numerous times, sometimes even during the day.

There's a bed in the back bedroom upstairs, complete with handmade quilt and antique headboard. It has been reported many times that it appears as though someone has slept in the bed recently. There is an impression of a body on the bed, as if someone had laid down to rest. The workers (or anyone, for that matter) are not allowed to lie on the antique bed. Furthermore, after

The haunted bed upstairs in the Restoration House—do phantom ghosts like to sleep here?

tour guides straighten out the quilt, they arrive later in the day to find the imprint of a body once again appearing there.

Lights have also been known to go on and off all by themselves. Locking up at the end of the day, the employees will shut off all of the lights in the building. Upon leaving the house, they notice on occasion a light still on upstairs.

Still others have reported being "touched" down in the basement where the jail is located. It's as if some invisible force reaches out at you from behind, grabbing and pulling at your hair. But when the individual turns around to look at who is being so mischievous, no one can be found.

With several stories under our belts, members of Twin Cities Paranormal Society and I, the fearless ghost writer, set out for an investigation. The Restoration House is no stranger to TCPS; the group had visited the building back in 2007. While not much evidence turned up during the earlier visit, members were eager to visit the historic building once again. Following is a breakdown of the previous visit in November 2007 by TCPS.

The temperature was 30.2 degrees, barometric pressure 30.11 in Hg, wind at sixteen miles per hour and the moon 30 percent full. TCPS had four teams for the frigid night in November, so there was plenty of manpower to find the paranormal. During the investigation, several teams had reported multiple camera malfunctions, and one member of the team in the basement noticed a significant temperature increase of more than 10.0 degrees. They could not determine the cause of the temperature increase. The team upstairs did, in fact, notice the bed, where it appeared as though someone had lain down in it.

Base EMF readings were near zero throughout the house. However, twelve minutes into the investigation, the EMF meter spiked for the upstairs team. Then, when asked if that was caused by a spirit, the EMF meter spiked once more. At that moment, the team unanimously felt the temperature drop in the room. TCPS continued to ask questions and received many responses via the lighting up of the EMF meter.

Later on in the investigation, TCPS captured what sounded like the front door opening, followed by footsteps and loud banging noises from down on the main floor. Upon further investigation, it was determined that nobody had been on the main floor at the time, so the sounds remained a mystery.

One of the TCPS team members was drawn to the upstairs room full of dolls. When he asked if the ghosts like to play with the dolls, the EMF Meter lit up solid.

In the basement of the Restoration House (including the jail), TCPS members had a few unexplainable camera malfunctions. Loud banging sounds, like a large metal door, could be heard on the audiotapes, while the members at the time did not recall hearing them.

Lastly, several TCPS members noticed the disheveled bed, as if someone had sat down on it. In the end, TCPS could not state that the Restoration House was officially haunted. Members did admit to having some strange things occur, including personal experiences.

TCPS would now get another chance to investigate the Restoration House. It was more than three years later—would the ghosts still be there? Why not? Where else could they go, other than moving on? Perhaps the previous visit by TCPS helped the ghosts pass on to the other world. That should be a prime directive for any decent paranormal investigation team. TCPS is no exception.

With TCPS at my side, I was eager to visit the Restoration House, in particular the jail cell in the basement. That place is so cool and creepy. I hoped this time around that the heavy, two-hundred-pound iron door would

swing closed on me. Then again, they didn't have a key for the door—I'd hate to be locked up in there for the night or have to explain it to a locksmith at 2:00 a.m. that a ghost had locked me in.

More importantly to me, I really had no desire to go upstairs, where things were very creepy. Yes, the big "d" word: dolls. They had a room full of them. I'm pretty good with strange sounds in the dark or the occasional phantom mist or shadow figure. I'm thinking that I could probably handle a full-body apparition. But dolls in the darkness during the witching hour? Have you ever seen the movie *Chucky*? I have, and it still freaks me out. All I know is that they should probably have paramedics on hand for me up there in the doll room. Thankfully, TCPS has seasoned police officers on staff, who I'm sure are well versed in CPR. The only trouble is that I think they're just as concerned about the dolls as I am.

Not to be outdone by a room full of dolls, how about having mannequins darting out at you from the corners of various rooms? These life-sized dolls are dressed in period clothing and, if you're not careful, will make you scream like a little girl in the dark. I found myself stifling a yell or two as I went around corners, greeted by a plastic and lifeless body. And the icing on the cake was way in the back room. They had one mannequin lying in the center of the floor. I nearly tripped over the thing, almost finding myself dropping next to it. My face was as white as its own when I first saw it. Perhaps its arm reached out and grabbed my ankle. Who's to say what really happens with mannequins when the lights go out.

With our team a bit large, we decided to split into two groups. One group would go upstairs and the other down to the basement. As luck would have it, I got stuck with the group visiting with the dolls and mannequins. I set aside my fears and trudged forward up the stairs.

Thankfully, we started in the center room, far from the invading army of mannequins and dolls. Well, there was one doll, but it was confined securely behind the bars of a crib, although that realistically gave me little to no comfort. I've been told that demonic dolls move with lightning speed, able to leap cribs in a single bound. If that happened, so be it. I'd take one in the name of paranormal science any day. I just hope that there's film in the camera when it happens. That reminds me of the golden rules in paranormal investigating. Number one: don't die. Number two: If you're gonna die, look good. And I can't remember what number three is, but it's no doubt some combination of the first two rules.

Upon reviewing the room upstairs with the bed in which a ghost apparently sleeps from time to time, we decided that the story could easily be debunked.

The upstairs doll room at the Restoration House.

We searched the bed and could clearly see that it had imprints in it, just as the story claims. The trouble was that the imprints seemed permanent. Even after we straightened out the quilt on top, we waited only a minute and could tell that the imprints were coming back—unless, of course, the ghost was right there with us, sitting down comfortably just after we had finished straightening out the quilt. But that would be quite rude of the ghost.

We started with the standard ten minutes of silence. While I remained subdued and quiet, my mind was swiftly racing. *What about the dolls! The dolls I tell you!* I couldn't stop thinking about the possibility of devilish dolls lurking

just beyond in the darkness, waiting for their chance to pounce. I felt that at any moment one would fly across the room yelling, "Heeere's Chucky!"

As far as what I caught with DARREN, my audio recorder, there were a few things that appeared that are worth mentioning. The temperature upstairs at the Restoration House was a whopping forty-nine degrees. I swear I could almost see my breath. But what do you expect for December in Minnesota? Hopefully the cold climate didn't keep the ghosts away—or maybe we'd get lucky and hear their phantom teeth chattering.

At thirteen minutes, three seconds into my tape, two wrapping sounds could be heard. Will (from TCPS) acknowledges that he heard something. Just over a minute later, my audio captured a voice saying, "Light... bright." Could this be a child spirit, asking for its Lite-Brite toy? Possibly. This happened shortly after Will stated that "we're not here to harm you." Could the spirits be complaining about our bright flashlights in the darkness? Could be.

Moving into the mannequin room (in a slow and shuffling sort of way, I might add), a voice can be heard at eighteen minutes, one second, that says, "Let...go." Will had just got done talking about the K2 meter. About five minutes later, we heard chains rattling—definitely a spooky sound indeed. But upon researching the area, we determined that it was glass breaking across the street outside. Someone was tossing bags of garbage in a dumpster. Debunked for sure.

At twenty-eight minutes, fifty-seven seconds, a light darted across the floor in the center room and then up the wall before disappearing. I mentioned what I saw, and Tam (from TCPS) replied that she had seen a light earlier as well. We spent some time trying to re-create the mysterious light and see if it might be car lights from outside, but we were unable to debunk this one.

A few minutes later, we noticed a serious cold spot occurring. We immediately thought that there might be something paranormal flaring up, but we quickly debunked this one. We felt around the room until we finally realized that there was a cold draft coming up the stairs. Another one bites the dust.

As far as video evidence, I did catch one event. At eight minutes, thirteen seconds, you can clearly see what appears to be an orb flying across the back room by a mannequin on the floor. It was the same mannequin I nearly tripped over. The orb quickly flies away from the mannequin before disappearing. I'm not a big orb fan, as I believe that 99 percent of the time they are just dust or insects. But this occurred in December—I doubt there were many insects around at the time, except perhaps the dreaded Arctic

The central upstairs room of the Restoration House, with TCPS lead investigator Tam Prose watching for any paranormal events.

bees (I'm told they have a mean frostbite). And as far as dust, the trajectory of the orb wasn't a straight line, which is typical of dust particles.

The other interesting event for me was my run-in with a shadow creature. Well, at least that's what I think it was. While standing in the center room, I thought I saw something moving in the back room. It was a tall, slender figure, rapidly darting toward the bed as if running to jump on it. Odd indeed.

Most shadow figures seem to be seen from the corner of your eye. This was the case for me. I'd like to think that it was just an illusion, created by the mind when focusing on your peripheral vision. But it seemed too *real* to me. It felt clear as day.

Lastly, Tam, one of the lead investigators for TCPS, saw the crib move slightly. We watched for a while, but it didn't move again. Interestingly, the K2 meter was in there while we were investigating, and we received some interesting readings from it. Perhaps the ghost haunting the Restoration House is a child, eager to play in the crib and with the strange lighted K2 meter.

Eventually, it was time to switch locations. I was eager for the change in guard, anything to get away from the dolls and mannequins. Also, I would finally get some time to visit the jail in the basement. But was it eager to receive me? Regardless, the basement team went upstairs, while we went below. We talked briefly with one another, learning of any paranormal incidents the other team had. It's good to know if there's a particular event occurring, so the other team can back up the observation. Then again, sometimes it's good to say nothing (usually if it's a strong event), as to not taint the next team. In many cases, one can plant the seed of an event in a person's mind. That person will then be on the lookout for the event, sometimes fabricating things in his mind, *assuming* that the event will occur. It's really a judgment call whether you tell the other team about the paranormal sightings—you need to know your team and the environment. Personally, I'd rather be warned of a potential ghost than be utterly surprised. But then that's just me and my pansy ways.

The décor in the basement was macabre at best, though not necessarily in any disturbing way; the lower level was filled with bones, skeletons and cobwebs—but no real ones (so I was told). They use the basement as a haunted house during an annual Halloween festival. All I know is that the creepy things that were mingled among us down there certainly didn't make it pleasing. And I had thought that the upstairs dolls were unnerving! Having a creepy, oversized zombie head staring at you in the dark from the corner of the room takes the cake. And it was even more fun later when reviewing the video and digital still shots. There were several masks hanging around the area, each with its blood-red eyes seeming to follow you as you moved. Seriously spooky.

Obviously the jail cell was the highlight of the basement investigation. I had sat in it before, eager to find out if the door would close all by itself, or perhaps a phantom jailer from the past would shove me across the hard iron bed. And there's something to be said about sitting in an ancient, rusting jail cell with the lights off. Who knows what evils might still lurk within its iron bars?

As far as audio evidence, I captured a few things on DARREN. Right away, at three minutes, fifty-nine seconds, we caught two unexplained thumps. This occurred just after I had asked to be locked up in the jail cell. Immediately after that, you hear a mysterious and haunting voice say, "Do it."

At six minutes, twelve seconds, I thought for sure that something had reached out and touched me. But I believe that it was debunked, as I was standing next to a hanging zombie monster (fake, I think). It seemed that one of the zombie hands had reached over and grabbed my side. I'm thinking

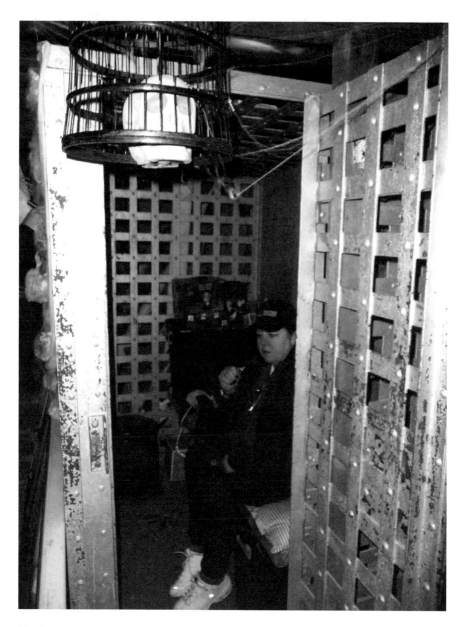

The basement jail cell of the Restoration House, with Tam from TCPS waiting for the door to slam shut.

that the zombie monster was bumped and swung close to me, making it feel like the zombie reached out and grabbed me. Or maybe it was, in fact, a real zombie monster. Then again, I don't believe I've turned into one, yet.

At seven minutes, forty-seven seconds, something brushed Will's face in the jail cell. We tried to debunk it, thinking that it might be spider webs or something similar. But there was nothing nearby. Similarly, Tam had the exact same experience later on while sitting in the jail cell, on the exact same side of her face.

There were several other times while investigating the basement when it appeared as though mysterious voices were captured on the audio recorder. None of them was decipherable, but something certainly seemed to be there, talking away.

At twenty-three minutes, fifty seconds, Tam felt as if her ponytail had been played with—lifted up and quickly dropped. We tried to debunk the experience, but it was not possible to determine what it might have been, other than something possibly paranormal.

For video evidence, we did catch another potential orb. This occurred at seventeen minutes, fifty-five seconds on my videotape. The orb appeared out of nowhere, curved around and then darted back into the darkness, out of view. And at nineteen minutes, seventeen seconds, all of us began to feel like something was definitely among us. It's a sensation that is difficult to explain to anyone who hasn't experienced it. Basically, you begin to feel the hair on your neck stand up, heaviness spreads across the room and over the top of you and, in some cases, it can get very cold and extremely quiet—like the calm before a storm. It's an odd feeling, for sure.

In the end, it's hard to say if the Restoration House is haunted. Sure, we had some personal experiences and a few possible EVPs, but there was definitely no smoking gun full-body apparition. If the ghosts were there, they were hiding quite well.

Still, Tam had some definite experiences inside the jail cell. Something kept touching her on the back and face. We tried to debunk it, assuming that there may be cobwebs in the area, but there was nothing nearby that would have caused the sensation. Further research by TCPS has still not been able to explain the event. Perhaps it was a spirit from the past, a criminal confined for all eternity to the jail cell in the basement. I wonder what sort of meal plan was in place for the eternal inmate.

The remainder of our visit to the basement of the Restoration House was uneventful. That's not to say that there are not ghosts roaming the building; it's just that no hardcore evidence could be found that night. Additional

investigations might provide more fruitful proof. Once again, I was left with a few good personal experiences but little hard evidence. What would it take for me to gain an unequivocal stance on the existence of the paranormal? I was ready for the full-body apparition or the haunting voices from the darkness to arrive (but still no evil dolls please). Yet so far, none of this on my journey into haunted Mantorville had occurred. Perhaps the next building would provide the evidence I needed to solidify my belief. I just hoped that I wouldn't die of a heart attack if a ghost jumped out at me.

# Old Log Cabin

On a side note, we decided to check out the old log cabin situated behind the Restoration House. The log cabin was built about the time that the Ginsberg brewery was built, about the mid-1870s. The owner of the log cabin was John Buehler, who was the cooper (barrel maker) of the brewery. All of the tools that he used are still there to this day, on display for all to see. No one

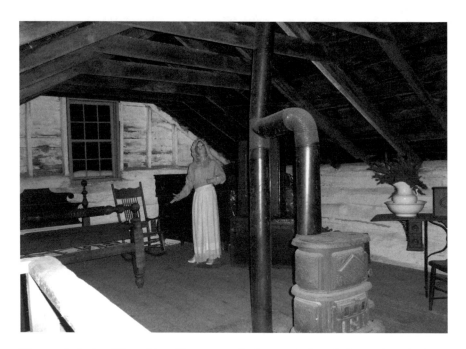

The upstairs in the old log cabin, with a mannequin that surprised me during our investigation.

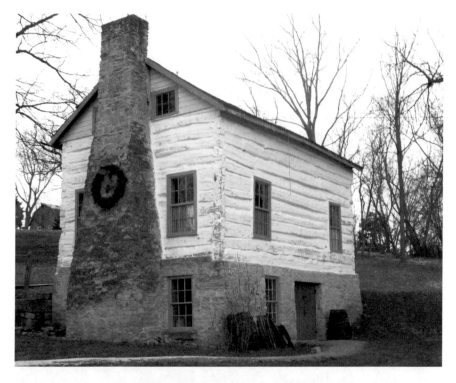

The old log cabin where lived John Buehler, the cooper of the local brewery back in the 1800s. Some say that he may still live there.

knows how long John lived in the log cabin, but it is safe to say that he moved on when the brewery fell on hard times in the early 1900s. Eventually, the log cabin was bought by the Mantorville Restoration Association (MRA) in 1985, and it was opened to the public for tours in 1987.

While there wasn't much to go on for ghost stories, I felt that it was important to check the place out. So, for a brief investigation, Will from TCPS and I walked over to the log cabin in the freezing cold of January. Needless to say, not much went on in terms of paranormal activity. I'm not sure if it was too cold for the ghosts or maybe just too cold for us.

We did find a couple EVPs after reviewing the audiotapes later. One, at two minutes, twenty-six seconds, is found after Will asks the spirits to speak to us. A voice is immediately heard saying, "Barrel keepers." Could this be John Buehler the barrel maker, talking about the barrels he made for the beer?

The main floor in the old log cabin, while Will from TCPS and I waited for the rocking chair to move.

The other EVP we caught occurred at sixteen minutes, forty-nine seconds. Will asks if John "made this barrel" (there was a barrel in the corner of the log cabin). A response quickly says, "No." That type of response leads me to believe that there may be a ghost haunting the log cabin other than John the barrel maker.

While the old log cabin was a great spot in which to look for potential paranormal activity, it definitely needed to be investigated more thoroughly. And if at all possible, it should be done at a warmer time.

# GRAND OLD GHOSTLY MANSION

The Grand Old Mansion, as it rightly states, is indeed quite grand. It stands on the west side of town in a Victorian colonial motif, elevated on a hill off Clay Street and overlooking the town like some all-knowing sentinel keep. Built in the late 1800s, it's one of Mantorville's most recognizable landmarks. More importantly, it's one of the more notable paranormal locations.

The house was actually built in 1899 by Teunis Slingerland Jr., who was the son of—you guessed it—Teunis Slingerland Sr. The importance of this is that Slingerland was at one point the wealthiest man in Dodge County. Hence the reason for the "Let's build a mansion" mentality.

Designed by F.D. Orff of Minneapolis, the mansion was of Victorian style, painted white, with a large attic above and wine cellar below. The mansion was known as the "House on the Hill" off Clay Street. When the Slingerlands passed away, they had no direct heirs, so the house ended up for sale shortly after the Great Depression. Walter Stussy decided to buy the mansion in 1939—for only $500.

Eventually, the house was purchased by Irene Pappas (who was Walt Stussy's daughter), who had grown up in the area and had always admired the house. Over the years, Irene restored the condition of the mansion and opened its doors to all those who wanted to tour it. Inside the mansion there were many antiques, a large doll collection (with perhaps a few demonic ones?) and a blood-red color motif throughout.

Sadly, I didn't get a chance to personally investigate the building. Sure, I had the opportunity back in 2007 with Twin Cities Paranormal Society. But

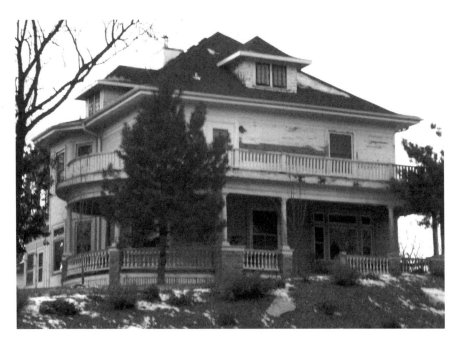

The Grand Old Mansion off Clay Street, also known as the Slingerland House, where an old woman can be seen staring out the attic window sometimes.

as I had arrived in Mantorville late, I couldn't connect with them. It didn't surprise me. After all, they were ghost hunting, with cellphones off and ears and eyes intent on finding the paranormal—and not some late-arriving author randomly driving around town.

At the time, I didn't know where the building was located. In hindsight, I look back and realize how impossible it is to *not* find the place. It's basically the only mansion in town, definitely the most prominent and a perfect place to house ghosts.

As I indicated, TCPS went out there in November 2007. There are several paranormal stories centered on the property. The most prominently known deal with sightings of an old woman watching from the upstairs attic window. She peers into the night, as if monitoring the town and keeping watch for anything out of the ordinary. Yet when you enter the house and search for the woman, she is nowhere to be found.

Some say that the old woman is perhaps the mother of the Slingerland boys, who inhabited the household back in the early 1900s. Others say it's Irene Pappas, who lived in it back in the late 1900s. Regardless of who it might be, the idea of an elderly lady eerily peering out from the upper attic

window gives me the creeps. Certainly not something I would like to see while walking my dogs late at night.

To add to the story, it's been said that before Mrs. Pappas passed away in the mid-2000s, she claimed that the ugly building next door would certainly burn down the day she died. She had made this remark to many witnesses in the town. The night of the sad day of her parting, the weathered and beaten wooden building just to the south of the mansion burned to the ground. To this day, it is not known what started the fire. Maybe it was the will of Mrs. Pappas, once and for all getting rid of the unsightly building. Today, a nice field of grass has replaced the ugly building. Perhaps that's why, to this day, Mrs. Pappas stares out the window, pleased with the new and improved view.

While I didn't ever get a chance to investigate inside, I do admit to driving by several times over the past few years while researching the town or taking pictures for my ghost books. During one of the drive-by runs, I thought I

A view of the Grand Old Mansion from the nearby vacant lot, where a building mysteriously burned to the ground via possibly paranormal events.

saw something moving in the upper attic window. Could it have been the old woman? It happened so quickly that I never got a clear picture of what it was. The only thing left was the image in my mind—an old lady in an apron, staring like a zombie out the window at the town before her. Strange indeed.

As I was saying, TCPS did an investigation there. Following is a recap of what they found. Weather conditions were ideal, albeit cold. Twenty-eight degrees outside temperature, barometric pressure 30.21, dew point 24.3, wind 8.75 miles per hour, and the moon was only 28 percent full. Eight investigators searched the mansion, along with the current owner. Everyone was excited to find out what sort of paranormal events would occur and if the old woman would appear. Within minutes of the investigation, loud thumping noises were heard on several occasions. Now when this happens, your first thought is, "Oh, the other team upstairs caused the sound." But after checking via radio, the other team had heard nothing.

Investigations almost always result in the sounds of creaks, bumps, thumps, lights and voices. What happens most of the time is that the paranormal team spends a moment sleuthing out the "normal" events—namely car lights going by, a furnace kicking in, other team members talking and, my personal favorite, the stomach churn. Yes, it seems that the stomach is one of the most famous sounds ever caught on audio recordings during investigations. Depending on what you ate, your stomach may sound quite demonic.

Seriously, though, one must rule out the normal sounds, which in turn will leave you with potential paranormal. Once you have a collection of possible ghost events, you can then analyze and research the environment and situation to better determine if it is truly something out of this world.

The night that TCPS investigated, members found other interesting events. EMF readings varied throughout the house, ranging from 0.1 to 0.4. A normal environment may be about 0.1. Hopefully, your house is in that range. Higher EMF readings can cause delusion, paranoia and vomiting, which can sometimes be misinterpreted as something paranormal. In fact, the problem can actually be attributed to improperly wired houses, where bare wires, poorly insulated wires or a multitude of wires are packed together. The EMF readings can go through the roof in some cases, literally. This is something a good paranormal investigation team will try to debunk immediately. In the case of the mansion investigation, TCPS could not identify the source of the sporadic 0.4 (and sometimes higher) readings.

At another point in the investigation, one of the team members experienced the scent of lilac flowers. Now, on a wonderful day in May, the scent could

easily be attributed to the numerous flowers across the landscape. But in November in Minnesota? Hardly. They searched for the source but could find none. The smell only lasted for a few seconds and then disappeared as quickly as it had arrived.

A few members of the team reported being touched by an unknown presence. I don't know about you, but having a phantom creature brush up against you in the pitch-black night would send me screaming out the door. TCPS members, however, would have no such thing. They are there to investigate; running away wouldn't do much good. No, with nerves of steel, they remain, standing tall in the face of fear, curious more than anything, excited to perhaps discover some serious paranormal activities.

These incidents occurred mainly on the first two floors of the mansion. While the incidents were interesting enough, the third floor had the strangest experiences of the night. What else would you expect from investigating an attic during the witching hour?

The first incident dealt with peculiar tapping noises multiple times during the night from various sections of the attic. It sounded like something was scratching or scraping at the walls. Perhaps it was the old woman trying to communicate? Well, in this case, TCPS debunked it as Japanese beetles flying around and tapping on the walls and ceilings.

The next event occurred and had chilling results. Multiple times the team found cold spots, but no source could be determined for them. It's usually quite easy to track down where a draft is coming from simply by shuffling around the room until you come to a door, window or open hallway. But in this case, TCPS members couldn't find an explanation for the chilly pockets of air. Does it mean it's paranormal? Possibly. Several team members also reported being touched by unknown entities in the dark.

Battery drainage occurred in multiple cameras that night up on the third floor, which is always a weird experience. I've personally had that happen to me and to this day can't explain it. The act of some spirit taking the energy from your battery is alarming, especially when you think about what it most likely tries to do to you. In some cases, investigators report feeling dizzy, like all the energy has been sucked out of their bodies. Perhaps the ghosts are doing it, similar to what happens to a battery.

Another recorded incident happened with the walkie-talkie radio, where it changed channels all on its own. TCPS members tried to reproduce the event but could find no way to do so. It was as if the radio "decided" to switch channels all by itself. Or maybe the ghost just wanted to have some fun.

The highlight of the active night occurred when the team clearly heard a phantom voice whisper, "Matt." The sound was caught on audio, and after replaying it numerous times, it was clear that the deep baritone voice had not come from anyone on the team.

One of the team members reported having the exercise machine that they were sitting on move. They experienced a "shoving" movement, as if something had pushed hard on the machine. The team analyzed the exercise bike, only to find it firmly planted on the ground.

Of course, what ghost investigation would be complete if you didn't hear mysterious footsteps in the night? This happened in the basement, heard by several different teams throughout the night. It sounded as if someone were walking in the kitchen above, slowing traversing from the dining room area to the sink. Yet when someone from the team ran up to the kitchen, nobody was there.

The last bit of information from the investigation came from the walkie-talkie. The team in the basement heard the lead investigator announce on the radio to come upstairs five minutes early. The basement team appropriately finished and went up top, only to find out that it was too early. When asked about the announcement, the lead investigator indicated that he had not said anything. Could this be a possible doppelgänger incident? A doppelgänger is a spirit creature that copies another individual, typically in the flesh. But could it possibly have happened with just a person's voice? Perhaps. Or maybe the house has a multidimensional portal in it? The team in the basement might have slipped through some time barrier briefly, only to show up back in the real world five minutes earlier.

The final analysis by TCPS on whether the house is haunted was ultimately inconclusive, which in my opinion is better than a solid no. It definitely warrants going back there sometime to look for the old woman in the attic window once more.

# CEMETERIES OF MANTORVILLE

What ghost book would be complete without a chapter on cemeteries? It seems that spirits and cemeteries go hand in hand, as they should. Zombies, I suppose, could be mixed up in there, too, but sadly, I didn't find any zombies lurking around in the cemeteries under the midnight moon. I wasn't too upset about it. Hunting zombies would be about as crazy as hunting for Wendigos—which, in my infinite wisdom, I've done, but that's another story.

There are several cemeteries in the Mantorville area, with Evergreen being the most notable. Evergreen is tucked into the hills, surrounded by, what else, evergreens. Located southeast of Mantorville down Cemetery Road, it is filled with tombstones, some dating back more than 150 years. Several are even for Civil War veterans. Other nearby cemeteries include Berne (in Berne), Concord (in Concord), Maple Grove (in Kasson), Milton (in Milton), Riverside (in Dodge Center), Saint Margaret's (in Mantorville) and Wildwood (in Wasioja).

Now, I don't know about you, but it always gives me the creeps when visiting a cemetery. I'm not sure if it has anything to do with knowing that someday I'll be buried in one—not to mention all of us eventually. Or maybe it's just the realization that there are hundreds of bodies buried below you. If the ground could talk, I'm sure there would be thousands of stories to tell among the graves. Of course, the ground can't talk—or can it? That's what I was hoping to find out.

I felt that it would be important to spend some time in Evergreen Cemetery, not only to possibly get a few EVPs, or maybe even a phantom

A front view of Evergreen Cemetery, the final resting place for many from the town of Mantorville.

figure or two, but also to get a better sense of what the town of Mantorville was like. Believe it or not, you can get a decent amount of information about a town just by walking through its cemetery.

Evergreen Cemetery was originally known as Old Burial Grounds before 1857. No one knows how long the cemetery has been there—it could have even been used by Native Americans decades before the settlers. Eventually the six-acre plot was named Evergreen. In 1869, a forest fire starting in Pine Ridge spread quickly through the area, and to this day you can see some of the tombstones still blackened by the fire. I wonder if the ghosts think about the fire and charred tombstones. Might that possibly upset them?

An additional six acres was donated in 1893 by J.N. Crandall and became known as the "Crandall Addition." Another notable artifact among the tombstones is a vault, donated by Cordenio Severance in 1926. It became known as the "Severance Memorial Vault."

While Evergreen is an old cemetery, some of it is also very new. There are many plots vacant, and some tombstones are new—within the last few years. As I recall, I have an uncle-in-law buried there. I remember going to the funeral, but I couldn't seem to find the grave site. I wondered briefly if

An interesting monolith surrounding the gravestones of the famous Slingerland family in Evergreen Cemetery.

I might bump into a relative in my evening stroll through the cemetery—in a ghostly sort of way. I could handle that. Running into a ghost you know is much easier to deal with than some stranger, in my opinion. Yeah, right—a phantom from the spirit world is spooky regardless.

I continued my walk through the cemetery just as the sun fully set. Darkness blanketed the area, sending moonlight shadows from tombstones and branches across the land. Scenes from countless horror movies battered my mind, making me question if perhaps they might be real. At any moment I expected a zombie to crawl out of the ground, grabbing my ankle and wanting to eat my brains. Or maybe I'd find a werewolf howling in the distance, eagerly waiting for me to come closer. Thankfully, none of this occurred.

In doing research for this project, I discovered a few tragedies in the past. To verify their authenticity, I wanted to at least find their gravestones. One such tragedy occurred back on June 15, 1870. Camellia, age eleven and daughter of A.R. Cohoon of Mantorville, died tragically in an accident involving a runaway horse. After an exhaustive search in the cemetery, I could not find any tombstone with the name "Cohoon" on it. The tragedy, of course, could have led to hauntings. It seems that ghosts of tragic circumstances are more common. After all, how many happy ghosts do you run into?

A second tragedy recorded was the first murder in Mantorville. It happened on April 27, 1905, when Henry Boge murdered Sophia Boge with a pickaxe. I'm not sure about you, but this certainly could be the makings of a horror story. I wondered if their spirits still lingered around Mantorville, agonizing over the tragedy that occurred. I also wanted to find Sophia's tombstone, but alas, I couldn't find it anywhere in the cemetery.

Another tragic event in Mantorville occurred on December 28, 1857, when Baltz Scheisser took his own life at the Main Street Saloon. This happened on the same night his saloon partner, Elmer Greeney, also died. Tragic indeed, and possibly another source of the many hauntings in Mantorville. Alas, I could not find either of their tombstones in Evergreen Cemetery. They might have been buried somewhere else, though.

One notable event for me while walking among the dead happened several minutes past sunset. As I wandered around, snapping pictures all the while DARREN collected information, I had the distinct feeling that someone was watching me. Was it the angel atop the nearby tombstone? Was it the crows in the distant tree, cawing every now and then? No, I think that feeling came from the ground. I'm not saying it was a creepy feeling, one full of evil or danger. It was just a type of pressure, or weight, like something heavy was pressing down on you.

That was the only strange incident that occurred at Evergreen. The only other thing that seemed odd was the vault, hidden in the northwest section of the cemetery. Built into the hillside, it's only visible if walking farther to the

The mysterious vault hidden in the back of Evergreen Cemetery. Perhaps it is a crypt.

north, away from the road that winds through the cemetery. My first thought focused on the treasures inside. Could this be a crypt, hiding creatures of the night? I nervously snapped a few pictures, hoping not to awake any demonic beings from within.

The vault is the Slingerland Vault, and I'm told that it is used mainly for storage and groundskeeping equipment, which makes sense to me. But a crypt of vampires sounds much more impressive. Regardless of what was actually hidden behind the iron doors, I speedily moved along to search among the other graves for restless souls.

Of course, to me all souls within a cemetery should *not* be restless. After all, they have made it to a final resting place—at least their bodies, that is. So it seemed to me that I wouldn't find anything seriously paranormal lurking about. And honestly, I didn't. Of course there were other cemeteries to check out—perhaps they contained the restless ones.

Due to timing constraints, the only other cemetery I visited was Wildwood, out in Wasioja, which was just a few miles northwest of Mantorville. Why visit this one? Well, it was another cemetery with a rich and ancient history. Most notably, it was just up the road from the Seminary Ruins and Civil

War recruiting station. And with that, I'm sure there were numerous Civil War veterans buried at Wildwood, not to mention a few seminarians. Unfortunately, I will never know, as when I arrived at the cemetery, the gate was locked, barring any entrance. Or maybe the gate was keeping something in? Regardless, I didn't feel it right to enter a cemetery unwelcomed. The last thing I wanted to do was become a permanent resident there.

There were some interesting things that happened up there at Wildwood as I stood and stared over the fence at the rows of tombstones. A nearby light from a pole illuminated the landscape, making everything glow unnaturally. But the light didn't bother me as much as the howling in the distance. Did I finally find my werewolf?

The sound is eerily caught on tape. You can hear me mention it as well, wondering about the exact location of the howling. I was hoping for it not to be too close, although I was only a dozen yards or so from the safety of my car. Yet I had a feeling that the car wouldn't save me from the claws of a raging werewolf. Can you say *Canis lupus* can opener?

Most alarming of all is the scream I recorded at fifty-two minutes, fifty seconds on my recorder. You can hear a definite, bloodcurdling scream right after I ask, "Make your presence known." The scream certainly got

The front gate of Wildwood Cemetery, where many Civil War veterans are buried; strange sounds and sights are also experienced here.

A view inside Wildwood Cemetery, where I heard strange howling sounds and captured multiple EVPs.

my attention. And I was sure it didn't come from the howling. Either way, I didn't want to wait around and find out. I'm pretty sure werewolves eat first and ask questions later.

As I walked to my car, I could hear whistling, like someone was whistling a song nearby. Could it be a ghost of a Civil War veteran, smiling and whistling away his cares because the war was over? Or maybe it was the spirit of a seminarian on his way to the chapel? It's hard to say what it was.

Trying to do paranormal investigations outdoors is like asking for directions at a compulsive liars conference. The information you get on your recorder or video could end up being just about anything. The paranormal truth is virtually impossible to verify for outdoor investigations—there could always be something in the distance making the noise, or maybe it's the wind picking up. Still, there is the potential of getting personal experiences, which is good for something. At least you can walk away (or run frantically, depending on the experience) knowing that something happened, even if it's hard to prove.

# BURIED ALIVE AT THE DODGE COUNTY HISTORICAL SOCIETY

The Dodge County Historical Society, located north on Main Street, was not always a building containing gems of its county's past. Originally it was a church, Saint John's Episcopal, its pews filled with congregation each Sunday morning. Pastor Peter Ruth was at the helm, with his wife, Sarah Anna, at his side until she died; rumor has it that she was buried in the basement of the church.

In the fall of 1863, Pastor Peter Ruth and wife Sarah Anna Henry moved from Ohio to Minnesota, looking for a new life, one that was fresh and vibrant. As luck would have it, they found the newly formed town of Mantorville and immediately began evangelizing, starting in a vacant store off Clay Street. Their dream was to someday create a church atop the nearby hill overlooking Mantorville.

In 1867, their dream became a reality. Work began on the church, setting the cornerstone in place laid by the honorable Bishop Whipple. Various artifacts were put in a glass jar, such as coins, Sarah Anna's prayer book and certain publications of the day. Sadly, Sarah Anna never saw the completion of the church. She died on May 10, 1866, and her body was taken back to her hometown in Ohio. Her last will and testament stated that she wanted to be buried in the basement of the church, beneath the altar of the west chancel. She wanted her husband Peter to be buried by her side eventually. Unfortunately, there were several wills, each with conflicting information. But in his best efforts, Pastor Peter Ruth had her remains moved from Ohio and buried in Evergreen Cemetery. But it is reported that upon the

Dodge County Historical Society, formerly the Hilltop Church, where the pastor's wife is reportedly buried in the basement.

completion of the church, her body was exhumed and placed somewhere in the basement. The exact location is still unknown, as no grave marker was ever erected.

Now if that doesn't set up the perfect ghost story, I don't know what does. To make things even more complicated, Pastor Peter Ruth was never buried in the church basement. Might that leave poor Sarah Anna in turmoil, lamenting over her final resting place being separated from that of her husband's? Quite possible.

The last church service for the Hilltop Church, as it had come to be known, was in 1928. The building essentially remained vacant until years later, in 1949, when it opened its doors once again, this time as the Dodge County Historical Society and Museum.

Now that the building was more or less a museum, hundreds of artifacts were collected over the years, helping to fortify Dodge County's rich history. One might think with the county being far south of the Twin Cities and being settled much later that it would not have a very detailed history.

Dodge County, Mantorville included, was settled more than a decade before Minnesota became a state. As it were, there is actually much to discuss about its history.

With the building's native limestone foundation and walls (from the local quarry), the old church definitely could have paranormal activity. No doubt with its background as a church—including all of the funerals that may have occurred—there is a great deal of emotions and energy wrapped up in the structure.

Perhaps there is also turmoil with Pastor Peter Ruth himself. It's interesting to note that he had been married several times, with Sarah Anna being his second wife (it's also fascinating that his first wife was named Sarah Anna, too). Not much is known about Pastor Peter's life, but we do know that he died in 1894 at the ripe old age of eighty-one. He is buried in Evergreen Cemetery, but *not* the one in Mantorville. This Evergreen Cemetery is in Pomona, California. Strange indeed.

An additional story goes that when the church was closed and boarded up, local boys in the area broke in through the basement windows, with plans to dig Sarah Anna up. Now, I'm not sure about you, but I'm thinking that's probably one of the craziest things to do. A typical rule when dealing with the spirits of the dead is to not try to provoke them. Digging a body up is most likely the ultimate provocation. I can only imagine what would happen if they actually succeeded—what hauntings they would have brought back to their homes? Thankfully they never found the body. This makes you wonder if it is, in fact, buried there.

Regardless of whether Sarah Anna Ruth was buried there or not, strange things have happened in the building, most notably in the basement, which is no surprise to me. That's not to say that other things couldn't happen up top on the main floor. For one thing, there are countless historical artifacts sprawled across the museum. It is quite possible that some of those items have spirits attached to them, providing for an easy avenue to ghostly hauntings. Sometimes, after people die, they leave imprints on very important objects they once owned. This attachment remains for years, if not decades, in the form of energy. Then, when someone walks by, the energy can be released, possibly in the form of residual hauntings, with evidence being captured via pictures or sound. The energy can also be released in the form of other objects being moved, such as in poltergeist phenomena.

As for myself, I had a somewhat uneasy feeling while walking around the museum, like a dozen eyes were staring at me, yet only the manager was in the room at the time. The atmosphere inside had the same feeling you get

at some old antique stores. The place was no doubt filled with a plethora of knowledge and history. One can only wonder what stories could be told if the artifacts could talk. In some cases, that's exactly what may be happening.

Some employees do not want to work there alone, specifically down in the depths of the old limestone basement. In fact, the main claim reported in the Dodge County Historical Society building is that of being touched. To this day, one employee in particular had a frightening experience down there. They will not divulge exactly what occurred to them but have sworn never to go down in the basement by themselves ever again.

The Twin Cities Paranormal Society (TCPS) had visited the place back in November 2007. An arrangement had been made to visit the building, based on prior requests from employees, to investigate the strange happenings going on. This was typical of most paranormal investigating groups, where families or businesses contact them for help. The owners have encountered something odd happening, something they can't explain or understand. It appears to be a supernatural occurrence; whom better than a supernatural team to find out what's really happening?

The temperature the night of the investigation was a balmy twenty-eight degrees, typical for a frosty November in Minnesota. Barometric pressure was 30.21, wind 8.75 miles per hour and the moon was 28 percent full. It was definitely a good night for ghost hunting.

TCPS members, along with all who have visited the Dodge County Historical Society, were eager to find out if in fact the place was haunted. During their investigation, they had numerous EMF spikes, which could either be attributed to poorly wired electricity or real paranormal events. Unfortunately, they could not prove or disprove any of the spikes, as the building on the main floor was filled with countless historical artifacts. They could not determine where the wiring was located.

Unfortunately, there was not enough time to do a lengthy investigation. As it were, TCPS only had the EMFs and some undecipherable voices that showed up. That's not to say that the place isn't haunted. In the end, it is definitely a location to reinvestigate down the road. In fact, I was planning on getting that done for this book. It was to be the highlight, with me hopefully finding the Holy Grail of the paranormal: a full-body apparition. I was bracing myself to meet Sarah Anna face to face. I even would have been happy with being touched down in the pitch-black basement. Unfortunately, once again due to timing constraints, neither TCPS nor I were allowed in. It makes me wonder if perhaps there's more going on here than one would believe. Maybe there is something being hidden down in the deep, dark depths of the basement?

Seriously, though, I don't believe that the owners of the Dodge County Historical Society are hiding supernatural incidents from TCPS or anyone for that matter. Like anything in this day and age, it takes money to operate a building, along with personnel. And trying to coordinate a paranormal investigating team to be available on a certain date can lead to a meeting that will never happen. Perhaps in the near future the Dodge County Historical Society will have time for TCPS to show up once again, this time to spend the entire night searching for paranormal happenings. Perhaps that is exactly what Sarah Anna is looking for—to have another moment with us to tell her story, so that she can finally be at rest.

# HAUNTINGS AT THE HUBBELL HOUSE

The Hubbell House, by far, is one of the most intriguing establishments in Mantorville, if not in the entire Midwest. With its roots founded in a time before Minnesota was even a state, there is a long and rich history about the place. And along with that, there be ghosts.

It all started back in 1854, when John B. Hubbell came to town and constructed a log hotel for those traveling between St. Peter (Minnesota's original state capital) and the Mississippi River in Winona. That same year, Frank Mantor staked claim to the land, and it quickly became known as the village of Mantorville. At that point, the town was officially incorporated.

The original Hubbell Hotel was a log cabin, sixteen by twenty-four feet long, and was the only building in town with a double roof, giving the guests extra room to relax in. Within two years, the present stone structure we know of was built. It is a three-story building made of limestone from the local Mantorville quarry. It originally had a two-story piazza, like the kind you see in the French Quarter of New Orleans. The newly constructed limestone building was opened on Thanksgiving Day 1856 to a crowd of anxious patrons.

While the hotel was generally full of business, ownership of the Hubbell House eventually changed hands in 1861, to C.T. McNamara. The hotel reigned supreme in the area for decades until in 1934, when a mysterious fire swept through the place. The headline of the *Mantorville Express* read, "Flames Break Out in the Historic Hubbell House, One of the First Hotels in Minnesota Damaged Extensively." The exterior piazza was a total loss.

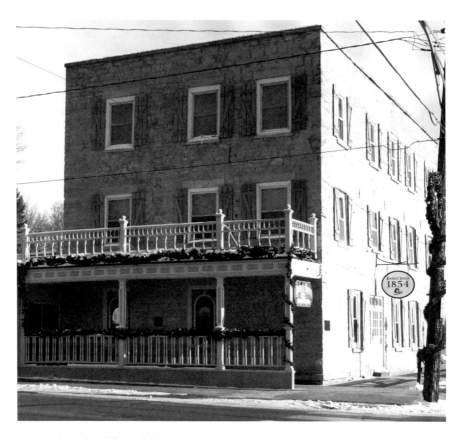

A front view of the Hubbell House, one of the most haunted buildings in town.

In 1939, Walter Stussy bought the Hubbell House for a mere $500. Mind you, this was only a few years after the Great Depression, so much of the land and many of the buildings across the country were very inexpensive. Still, the building itself was in serious trouble, to the point of demolition. Thankfully, Paul and Irene Pappas eventually bought it from the Stussys, turning it into an "old country inn." From there, the rest is history, with the Stagecoach Saloon opening in 1975. Eventually, son Don Pappas took over the business in 1996. Today the Hubbell House staffs 95 employees and seats 350 patrons and is a nationally registered historic site.

Notable guests who have visited throughout the years have included U.S. Navy admiral Beatty, magician Harry Blackstone, President Eisenhower, Joe Garagiola, General U.S. Grant, journalist Horace Greeley, Twins first baseman Kent Hrbek, Lady Bird Johnson, Twins first baseman Harmon

Killebrew, movie star Fred Macmurray, Mickey Mantle, Roy Rogers, Bishop Whipple and General Sherman.

With so many popular guests, there is certainly the possibility for energized spirits in the building. And with all of the limestone, lots of energy could be held within the walls. What is also interesting to point out in terms of history is the departure of John Hubbell. While he came in and helped build the great town of Mantorville, his leaving remains a mystery. Nobody is quite sure when he left or how, nor whether it was on good terms or bad. It's as if he disappeared entirely. Or maybe he's still at the Hubbell House, buried underneath the stairs and haunting the halls late at night.

As I have indicated, there is definitely a rich history with the Hubbell House. Hundreds of thousands of people have come through the front doors over the past 150 years. And some, of course, have never left. There are several occurrences of tragedy at the Hubbell. One notable case occurred back in the 1950s. An elderly man fell down the steps to the basement on his way to the restroom. Another tragic incident dealt with an employee who sadly took his own life, hanging himself over the same steps leading to the basement.

What's interesting to me is the coincidence of having both deaths occur in the same location. Are they related? Is there some demonic force at work in the basement of the Hubbell? Perhaps. Of course, that's exactly what Twin Cities Paranormal Society and I wanted to find out.

Probably one of the most exciting points in writing this book was getting the opportunity to investigate the Hubbell House. Not only because it is reportedly one of the most haunted places in Mantorville, but also because we (TCPS and myself) would also be the first paranormal investigation team to enter. TAPS (from Jason and Grant's *Ghost Hunters* show on the Syfy channel) had asked to investigate the Hubbell a few years back, but ultimately they were not able to make it.

The initial highlight of the night was having dinner at the Hubbell House. I did not eat there that evening but have done so numerous times in the past. It's by far the best food around! TCPS came down early from the Twin Cities and had a delicious meal. I highly recommend stopping in for dinner, and don't be afraid to ask around about the ghost stories.

There have been countless reported paranormal events throughout the years at the Hubbell House. Numerous patrons and employees have encountered "things they can't explain" while either working behind the scenes or attempting to eat a delicious dinner. Most of them stem from "whispering voices" while eating or cleaning later in the night. Many patrons

are confused by the soft voices, coming from no one but heard just a few inches away from their ears. When they turn to look, nothing is there of course. Or at least nothing that they can see.

Several people claim to have been touched by an unknown presence. Most of these cases come from employees working later in the evening. Others will assert that objects move all on their own. One employee was busy filling a water glass from a pitcher only to watch the water glass shift, tilting sideways and heading off the table to the ground. She reached for the glass, but the glass steadied itself on its own, resting comfortably back in its original position. This occurred in the original kitchen area, off to the right when you walk in.

Eyewitness Ann Driver (who graciously assisted us on our investigation— thank you Ann!) stated that at one point in one of the back dining rooms she saw cigar smoke wafting into the air. When she surveyed the area, she could not find the source. Smoking hasn't been allowed for a number of years at the Hubbell House. What's important to note is that this appears to be a recurring theme, where supposedly the ghost of Mr. Hubbell will travel out into the dining room, smoking, with a strong scent of cigar everywhere. While Ann did not see any apparitions, the cigar smoke and smell were enough to send chills down her spine.

Other classic poltergeist incidents have happened over the years in the old hotel, namely with lights going on and off or music on the stereo system going on and off by themselves. Employees will be leaving an area of the restaurant and turn the lights off (or music), only to find them back on again a few minutes later.

Of course, the wildest claim coming from the Hubbell House is that a janitor took his own life and haunted the hallways for several days before being found. It was reported that employees would pass by him after he had died, thinking nothing of it, since he was the janitor and no doubt off fixing something in the old building. It wasn't until several days later that they found his body, and everyone was confused to say the least, as they had seen him walking around over the past several days.

I can tell you firsthand that some of this claim has to be false. For one thing, the janitor was found over the basement steps, which are open and easily seen by employees walking around in the back areas. So it seems to me that it would be pretty difficult to not know that he had passed away. Still, there is the possibility that the janitor was removed from the building right away, without most employees learning of the tragedy. Then I could see some employees seeing the janitor in the hallways, not knowing

that he had died. Even that, in my opinion, would be difficult to believe. Having an employee pass away at the place you work would be serious news and spread fast—not only in the building but across the small town of Mantorville as well.

There is one possibility this ghost story is true, however. There is another entrance to the basement, way in the back. But that has been boarded up and unused for decades. I could see this happening there, and then nobody would have found him for days. Might this be the real location? In my investigation, I was not able to decipher the truth. So I suppose the legend lives on.

Now that you have a better understanding of some of the reported paranormal incidents occurring at the Hubbell House, perhaps it's time to delve into the world of investigations. As I have said, TCPS was the first group to officially check out the place for paranormal activity. With that in mind, extra caution was put in place to ensure that everything went smoothly. With Tam and Will at the TCPS helm as lead investigators, I was sure that things would be perfect. All we needed was a little cooperation from the spirit world. And thankfully we got it.

The night of ghost hunting started shortly after 10:00 p.m., which is when all the patrons of the Hubbell House restaurant dissipated. Well, there were a few stragglers, slowly sipping on the last few drops of wine in their goblets (Ghost Pines Chardonnay was the wine of the night—coincidence perhaps?), so we kept it kind of cool during the setup. It's one thing for a patron to get freaked out by something paranormal, but it could be far worse getting freaked out by a paranormal investigator. It seems that those who don't believe don't like to see those who do. It creeps them out even more than ghosts, I guess.

We had all of the standard equipment for the investigation: Mel meter, K2 meter, audio recorders, video recorders and digital still cameras. We even had a laser device, sending little dots of light across the room in which we had set it up. The laser helps catch shadow figures, supposedly. I just thought it looked pretty cool, like a high-tech disco ball. I wondered what the ghosts thought of it.

Command central was set up around the corner near the main lobby desk, with all of the stationary cameras feeding to it. The configuration TCPS used was very professional, just like what you see on the ghost hunting shows on TV. TCPS, naturally, *is* very professional. In my opinion, this is a critical attribute to have for this type of business (or any business for that matter). The last thing you need is some amateur group coming in to investigate your

house or building or establishment. For one thing, they could make things worse, disturbing the already restless spirits further. They also might take your claims of supernatural activity as a joke, which will make things worse for yourself. Finally, an amateur group may physically damage your home or building, what with all the cables running throughout for the cameras or just the sheer fact that you have eight or nine people tromping around with the lights off.

After a quick walkthrough with Ann, TCPS was ready to go "lights out." We split up into two teams, as we had nearly ten individuals investigating. Tam, Julie, Ann and I started in the basement. Will, Dan, Mike and Lily took the upstairs third-floor level. As with any investigation, we began our

The basement of the Hubbell House, where it is reported that two people have died, possibly adding to the hauntings.

search for the paranormal with ten minutes of silence. The ten minutes of nothingness can take forever or can take but a moment. It depends on your attitude. If you're anxious to start asking the spirits your questions, the time seems to drag on. But if you get into the moment, trying hard to put yourself among the spirits, ten minutes races by rather quickly. As for me, the time slowed down and seemed strange, like it had stopped altogether.

It was mostly pitch-black down in the basement, as there were no windows allowing any light in. I kept staring further into the darkness, thinking that I could see shadow figures darting in and out. I watched this for several minutes, like the ghosts were playing with me. It really freaked me out, but I chalked the experience up to my eyes playing tricks on me while adjusting to the darkness. All I can say is that it felt really bizarre, to the point where I wanted to head back up.

With the ten minutes of ghostly quiet time complete, we began our questions. We asked the typical ones: "Can you show us a sign of your presence?" or "What is your name?" or my personal favorite, "Did you die down here?" In the few paranormal investigations I've been on, I've never heard a response from it, nor do I believe I want to.

Eventually we let the spirits know that they could touch us. This is after TCPS asked us (myself and Ann) if it was okay. Being the chicken that I am, I wanted to say no. But what fun would that be? Wouldn't it be exciting to actually be touched by a supernatural force? I wouldn't mind it, I guess, but I'd probably have to change my shorts afterward. Either that or I would be joining the spirits from cardiac arrest (touching TCPS members like crazy in retribution, no doubt).

Most of us carried a digital audio recorder, and I put mine (DARREN) in an old abandoned walk-in freezer, or maybe it was a refrigerator. I set it down, hoping to catch some kind of paranormal anomaly. After reviewing the tape later, one thing I caught (four minutes, thirty-eight seconds on tape no. 30) was an unusually loud thudding noise, like something heavy was dropped. As I recall, there was nothing in the freezer, and I know nobody was nearby at the time. It definitely didn't sound like something falling in the distance; it sounded as if it had occurred within a foot or two of the recorder. Could it be a residual haunting, perhaps from a chef dropping lamb chops onto one the freezer shelves? Possibly.

The other event I caught while DARREN was in the freezer occurred at five minutes, sixteen seconds, where a whispering voice can be heard saying, "I insist." The voice is a bit sketchy, definitely a Class B EVP, so it honestly could be saying just about anything. But you get the picture—

something said something inches from the recorder when nobody was nearby. Strange indeed.

At twelve minutes, nine seconds (with my recorder moved near the front of the basement by the steps), I caught loud thumping. After checking via radio with the other team, though, it was determined to be the other team upstairs moving around. Debunked for sure.

Next, those same shadow figures I had seen initially during quiet time came back. At sixteen minutes, thirty-three seconds into the event, I mention on the recorder that I was seeing a dark black mist of some sort. This is often attributed to shadow creatures or, in some cases, ectoplasm (although ectoplasm is typically white or gray in color). I began to wonder how many creatures of the night were rummaging through the basement in front of our noses and at what point we might bump into one. I'm not sure who would be more alarmed, the ghost or myself. Chances are it would most definitely be me.

The other interesting event focused on louder thumping. They were pretty consistent, it turns out, about every ten minutes or so. After further investigating, it was very clear that we were hearing the pilot light for the large furnace coming on. After all, this was the middle of January, and trying to heat a 150-year-old building took a lot of juice.

As far as additional findings in the basement, here are a few other notable events I captured on my audiotape: at twenty-nine minutes, forty-five seconds, the K2 meter lights up solid immediately after asking if we should leave; at forty-two minutes, fifty-two seconds, Tam mentions that it feels like something is hiding down here in the basement with us; at fifty-one minutes, thirty-seven seconds, Tam and Julie hear music playing, a high soprano voice close by, but we couldn't find the source; and at fifty-six minutes, twelve seconds, a strange clanging sound is captured, like glass breaking, and then followed immediately by a soft, eerie moaning.

Our basement team spent some time in the front area at the base of the stairs. If you recall, this is the location where the two individuals had supposedly died. If there was any spot that would contain spirits, I would think it would be by the steps. I have to say that it felt quite uncomfortable sitting down at the base of the stairs, knowing that two people had died in that exact spot. Visions of the incidents flashed through my head. I began to wonder if the visions were of my own doing or possibly imprinted by another force? Might the spirits be replaying the tragic events of the past in my mind? Regardless, the sensation made me once again want to leave the premises.

The highlight of the basement investigation came from the area way in the back (which may be the real location of the janitor who hanged himself). It was a confining space, with an old, boarded-up door no doubt used at one point to exit the basement. As Tam and I walked back there, we immediately could sense that something was different. A tingling sensation filtered through me, along with the hairs on my neck rising. This is usually a sign of some energy force at work. It was at that point that I questioned whether we should be back there.

It also got freezing cold, to the point where we thought we might see our breath. Tapping or scratching sounds could be heard from the crawl space we nervously peered into, wondering if at some point a phantom entity with beady red eyes would peer back at us. I thought I could hear voices back in the crawl space as well, making me feel even creepier, as if we were definitely not alone.

We started asking questions, and to our amazement the K2 meter was lighting up as if someone or something was answering them. Strange indeed. I can't tell you the feeling you get when that happens. There's a strong sensation of, "Wow! This is actually happening—I'm communicating with the spirits!" Well, it's hard to say that for sure. But for a few minutes, it really seemed like something was responding to our questions.

Time was up for our jaunt down in the basement, with the main floor waiting for us. I was eager to explore that area, as that is where the majority of the stories stem from. If the main floor was as interesting as the basement, this would turn out to be a very good night, from a paranormal investigating perspective.

The first part of the main floor investigation at the Hubbell House was somewhat uneventful. But finally, at nineteen minutes, twenty-seven seconds, something interesting happened. My faithful video camera shut off, all on its own. That's never happened to me before, and it really freaked me out. Not at that exact instant, mind you. At first I was trying to figure out what I had done wrong or if maybe there was some automatic shutoff. But I could not explain the incident. That's when I began to wonder about a paranormal explanation, thinking of how there might have been a ghost inches from me, its ectoplasm breath spraying across my face while it tinkered with my camera.

At twenty-seven minutes, forty-one seconds, Tam asked if it lived there. The K2 meter lit up. I wondered then if it was possibly Mr. Hubbell himself communicating with us. At that same time, across the other end of the dining room, I began to see something in the darkness. I couldn't

The main floor of the Hubbell House, where my video camera mysteriously stopped working.

explain what I saw at first, just something short, about four feet tall, darting back and forth down the hallway. I looked away and then back to the hallway area, and I swear that I saw something shiny floating in midair, like one of the glass lamps on the dining tables. But I blinked and it was gone. I did have the video going at the time, but upon replaying it, I found nothing to back up my observation. So the incident is left once again to personal experience.

At thirty-five minutes, six seconds, I went to pick up my audio recorder and, just before grabbing it, heard a voice on it saying something like, "Copy shadow." What's weird is that it really sounded like my own voice, but I don't recall saying anything at that moment. Could it be a spirit mimicking me? Or maybe a doppelgänger wannabe?

The only other events from the main floor were with Julie and her invisible ghost friend, as one seemed to be following her around, based on the readings on the EMF detector. Also, at fifty minutes, seven seconds, Tam began to feel like something was watching us, similar to what had happened in the basement, where she thought that something was hiding from us. It

The main floor of the Hubbell, in the hallway where I saw shadow figures.

appears now that it was much closer, whatever it was. I felt it, too—there was something there all right, but what or who was it?

Our final stop on the Hubbell House investigation brought us up to the third floor. We did check out the second floor briefly but found nothing supernatural or paranormal there. There was a large plant pulled apart in one of the rooms, like some mischievous poltergeist had been at work, dropping it from a top shelf. But Ann was not alarmed by it, so neither were we.

The third floor felt similar to the basement, like something was always just around the corner, hiding from you. It didn't help matters that the floors were severely uneven, giving you that ultimate fun house effect. There had definitely been some serious settling in the building. But what do you expect for a 150-year-old hotel?

Some interesting events captured on DARREN include the following: at twenty-one minutes, seven seconds, a cracking noise can be heard within the small room full of chairs, when nobody was in there or nearby. It sounded like some small pebble had been tossed across the room. Then again, it

The top floor at the Hubbell House, in the chair room, which was oddly blocked off from the rest of the area.

was January, and I could certainly see the sound coming from the building shifting. Not settling mind you, what with it being built back in the 1800s. Unless, of course, it was built on a swamp, which is entirely possible, given that the location is not at all that far from the Zumbro River.

At thirty minutes, eleven seconds, Tam and I began to see shadow creatures darting in and out of the vacant rooms along the hallway. They appeared to be of average size, with sort of a foggy consistency to the

apparition. Unfortunately, we did not get any video to back up the event. I may have caught one of the creatures on tape, though, as I will explain later in this chapter.

At thirty-five minutes, twenty-eight seconds, I went to get my recorder out of the chair room, and just as I entered I could clearly hear a female moaning sound. The voice seemed to be coming from within inches of the device.

At forty-one minutes, fourteen seconds, Tam asked, "If you light up the lights on the K2 meter, we will leave." The lights quickly lit up solid. At forty-one minutes, forty-four seconds, we asked again, to verify if we should leave. The lights lit up again. We promptly left the third floor.

On the way down to the second floor, I asked for the spirits to yell really loud next to the K2 meter. You can immediately hear a brief screaming sound. At the base of the stairs, I picked up an EVP that seems to say, "We really are here now." Perhaps the entity was trying to state that we really are *leaving* now?

By far the most alarming event on the third floor is what I caught on video. Before the investigation started, I decided that I should make a run through the property with the lights on, to get a baseline and help me orient myself later on while writing about this adventure. As I entered the dark third floor from the creepy, super steep and narrow staircase, I caught what appeared to be a white, phantom mist starting in the hallway area and then darting quickly into one of the pitch-black vacant rooms. The hair on my neck at the time was standing up, even though I didn't see any of this until reviewing the tape later. Regardless, I felt at the time that it was important to leave the third floor and return to the group.

So is the Hubbell House haunted? Well, based on tangible evidence, it's hard to say an absolute yes, in my opinion. But based on personal experiences, there is definitely something going on. Perhaps you might want to stop by for dinner and find out for yourself? And on the way to the bathroom, don't hesitate to look around. Who knows what you may find—or more importantly, what may find *you*.

# MYSTERIES AND MUMMIES AT THE OPERA HOUSE

Mysteries and mummies may sound like something you'd find in a 1920s horror flick or some blockbuster movie of recent years. Yet we have it in our own backyard in Mantorville.

The Opera House, notably the most haunted building in Mantorville to date, contains such mysteries. We'll get to the mummy adventure later. For now, let's look at some of the history behind the Opera House, as well as its infamous ghost stories.

The location of the Opera House and Theatre Company was not originally a tall, two-story limestone building. It began, supposedly, as a log cabin in the mid-1850s, although this information could not be verified, with several residents living inside at the time—some say that this is when a child died of influenza and that a haunting mother still roams the building, grieving for her dead child. In about the 1890s, the Kundert Family Mercantile Store was built, providing goods and services for the small town of Mantorville. Sadly, in the early 1900s, the store was destroyed in a fire.

By 1918, the Opera House was finally built on the mercantile location. The building was designed by a man from Rochester who tragically died in a traffic accident. Some say that his spirit haunts the Opera House as well. Eventually, the City of Mantorville purchased the Opera House in 1940. Other notable times involve the building becoming a bar during the mid-1900s. It has also been used as a city hall and civic center. In more recent years, the building was owned by the Mantorville Restoration Association (MRA), and the Mantorville Theatre Company performs seasonal plays in it.

The front of the Opera House, the most haunted location in town.

The Opera House is definitely a haunted location, based on prior reports, including from Twin Cities Paranormal Society. There are too many accounts of supernatural incidents to say otherwise. Employees have reported hearing footsteps from the second floor above the green room, even though nobody is up there. Gray mist has appeared out of nowhere in the upstairs rooms behind the stage. A lady in white has appeared, in Victorian dress, coming down the stairs into the green room. Her name is presumed to be Ellen (based on the outcome of a séance that was performed in the 1970s). This lady in white (Ellen) appeared in the theater seats while an employee was working on painting the stage late at night.

One of the employee's dogs came to the Opera House once to keep the employee company. The dog, however, was not in the best of spirits. It kept barking at the corner of the stage room, as if something invisible was there (there are stories about a possible phantom cat on the premises—perhaps this is what the dog noticed?).

Lights would turn on and off all on their own during plays at the Opera House. In particular, there have been numerous reports that Ellen will physically pull the lights on the lighting board, dimming them at will during a performance.

Music can be heard sometimes late at night in the form of a piano playing from the upper balcony. It has been reported that a man who played piano there for many years died a few years back and has been haunting the Opera House ever since.

A man known as "Harold" is reportedly haunting the basement, throwing things from time to time at employees who venture there. He especially likes waiting for you underneath the steps. He is dressed in an old harlequin outfit, similar to a court jester. Countless EMF readings, EVPs and cold spots have been reported by various paranormal investigating teams throughout the past few years. "Ellen" likes to hide props for upcoming plays. The props will show up at a later date somewhere else in the Opera House.

A phantom teenage girl is reported to have been backstage, getting ready for a performance, but quickly vanishes before anyone can talk to her. There is also the story about the stray cat that died in the alley near the Opera House, witnessed by employees and patrons. It was reported later that night that others saw the same cat still wandering around. This may play into the "mummy" incident, which will be explained shortly.

So what can I say? Obviously, from the list above, there are a ton of paranormal claims. How could it not be haunted? Well, for me, it wasn't about proving or disproving its spookiness; for me it was all about proving to myself that hauntings unequivocally exist. As I've mentioned in the opening chapters, I'm still looking for the Holy Grail of ghost hunting: the full-body apparition. I hoped that there would be something like that when TCPS and I visited the Opera House again.

Both TCPS and I have investigated the Opera House in the past. Actually, TCPS has been there a couple of times. This leads me to further believe that something is definitely happening there. Otherwise, why would a paranormal investigation team bother coming again? So this would be my second time hunting for hauntings there.

I'd like to spend a few paragraphs recapping our past experiences in the building and then finish up with our most recent investigation. Twin Cities Paranormal Society first visited the Opera House back in April 2007. Members had heard about the countless paranormal events occurring and were eager to discover the truth among them. And with a location with buildings on it for well over 150 years, there had to be some type of supernatural events occurring.

The weather conditions were good during their initial investigation. The temperature was thirty-two degrees, barometric pressure 29.96, wind three miles per hour and the moon 6 percent full. Other than the 93 percent

humidity, it was a perfect night. Actually, high humidity may lead to better paranormal results. Some say that higher humidity allows for the spirits to travel better, what with electricity/energy traveling easier through water than air. As it turned out, there may in fact be some truth to that.

TCPS set up motion sensors and video cameras, as well as all of the normal equipment for ghost hunting. Within the first hour, they had results up in the balcony. The video camera had mysteriously become unplugged, and the nearby motion sensors had not gone off. Other equipment malfunctions occurred throughout the night. In most cases, the team had to "ask permission" to use their cameras. I wondered if they had to ask the ghosts for permission with anything else, like going to the bathroom perhaps.

I can relate to the "ask permission" incident. That exact problem happened to me when I visited the Opera House with TCPS later in the year, in November 2007. I was down in the basement, wandering around in the darkness, and decided that it was time to take some pictures. Unfortunately, my camera was not cooperating. I tried restarting it and pushing harder on the button, but nothing would work. Finally, one of the TCPS members told me about the "ask permissions." As soon as I asked for permission, my camera started working. That has never happened for me since.

Now, I don't know about you, but when you watch these things happen on television, you probably think, "Yeah, right. It's just a hoax." But when it actually happens to you, it really freaks you out. Of course, that was the whole idea in me ghost hunting—I wanted to find out firsthand if there was any truth to this. And if you read my other book, *Ghosts of Southeastern Minnesota*, you found out my answer at the time. Yet that day was a different day, and I was looking for more proof. Maybe ghost hunting is like a drug addiction? Once you get a taste of it, you always want more. Who needs meth, crack, Mountain Dew or several grandes of Starbucks espresso coffee. We've got ghosts!

But I digress. There are other things that happened to TCPS during its first investigation of the Opera House back in April 2007. For one thing, one of the members reported a chair backstage suddenly moving all by itself. It would be one thing to witness that from afar, but in this case, a TCPS member was still in the chair.

Later on, a sweet, fruity scent could be detected, but it dissipated quickly. Cold spots were recorded in both the men's and women's dressing rooms upstairs during the night. And at one point, the atmosphere upstairs in the men's dressing room became so thick that they could barely see their hands

in front of their faces. The dark mass lingered for a minute or two and then disappeared altogether.

TCPS team members felt like they were being watched many times throughout the night, in particular in the upstairs area. They also reported seeing shadow figures. In the basement, one of the members claimed to have turned and felt as if she had bumped into another TCPS member. But she turned her flashlight on and saw that no member was nearby. Seriously spooky.

During TCPS's initial investigation, members reported in their final analysis that the Opera House was indeed haunted. While they were unable to provide any concrete evidence, the personal experiences were enough to make the claim.

Now let's fast-forward to November 2007, when TCPS once again visited the Opera House. And I was fortunate enough to be along as a guest. Another incident occurred with the chair in the backstage room. This time, instead of moving across the floor, it vibrated radically, alarming the TCPS members. They tried to debunk the event but could find no logical explanation.

Footsteps were heard in the hallway upstairs, yet nobody was walking in that area. Shadow figures were also reported in the closet of the women's dressing room. The men's dressing room became dark for one of the teams during the night, as if someone or something was "closing in on them." This appears to be similar to the previous event upstairs, in which a dark mist apparently closed in around them, making it hard to see.

Footsteps and movement seemed to be coming from the closet in the women's dressing room. With this evidence, and the shadow figures coming from it, might there be a portal to another world here? Possibly. Who knows if it is Harold, Ellen, the architect, the piano player, the cat or something else. There are countless ghosts supposedly haunting the place. It could be any one of them or all of them.

Cold spots were reported in the men's dressing room, along with numerous camera malfunctions (similar to the previous investigation, where you had to ask permission). And let's not forget the picture of a ghost that TCPS caught. That's right, the image here is believed to show the ghost Ellen, sitting on her favorite couch. Previously it has been reported that Ellen gets upset when someone sits on her couch or when it is moved. Given that it is a prop, the couch gets moved often, which probably doesn't *sit* well with Ellen.

The main floor of the Opera House seemed to have the most activity of the night. Shadow creatures lurked in the darkness. A gray-colored mass

A phantom figure on a couch at the Opera House. *Courtesy Nathan Lewis, TCPS.*

moved near the box office door. The creature seemed to move to the right, walking right through the nearby wall. Perhaps that was a residual haunting, stemming from a time when there was no wall there.

Another TCPS team member saw a shadow duck down behind the railing of the balcony. From the balcony, a different team member noticed the shadow pass in front of the stage door, covered by a curtain. The shadow creature had actually blocked out the red color of the curtain for a moment. Additional experiences centered on the feeling that someone was watching the team members from close by, as if a ghost was right over your shoulder.

TCPS had the opportunity to investigate a previously locked room in the basement, located in the far corner. This room made several members of TCPS uneasy, but it should be noted that mold was found growing in the room. Also, a shifting sound was heard coming from the far back room. Upon investigating, nothing seemed to be out of the ordinary. Finally, the team in the basement could hear tapping noises upstairs, even when nobody was above them.

And now for the most recent investigation with TCPS. Again I was fortunate enough to be with the members, on a chilly day in December

2010. Yes, another winter investigation. I hoped that one day I would get the chance to investigate with TCPS during a more favorable time of the year. Of course, being that there's only two seasons in Minnesota (winter and road construction), I may be slightly limited in my opportunities.

We started our investigation in the basement, and right off the bat, at four minutes, nineteen seconds into my audiotape, I catch a Class B EVP stating, "It clicks." Okay, I'm not entirely sure that's what was said, but then again that's why it's defined as a Class B. Something was said, but it wasn't easily decipherable. Shortly after this, a brief moaning sound is captured on tape. But this I speculate being one of the investigators in the distance.

At nine minutes, forty-seven seconds, I hear another voice, but this is a Class C EVP—hard to decipher what it is saying at all. But then at twelve minutes, fifteen seconds, I capture a very loud bang occurring somewhere in the back room of the basement. The Opera House back room is my least favorite room in all of Mantorville. It is this room in which I experienced during my previous investigation the closest thing to a full-body apparition. While I could not see anything (as it was totally dark down there), I could sense some form of energy, some presence nearby as I stood there in the back room. My mind instantly painted a picture of Harold. He's the reported ghost dressed in a harlequin outfit. Regardless, it felt like he was literally inches from my face. I could almost feel the entity breathing on me. My immediate reaction was to back out of the room, which I promptly did. And it goes without saying that I didn't return until this most recent investigation more than three years later.

A creepy back room in the basement of the Opera House, where I experienced my first true paranormal event.

As I said, we heard a loud bang in the back room. Will from TCPS, one of the lead investigators, rushes in to determine the cause of the noise. There was practically nothing in the room. At best there may have been a vent expanding or contracting in the cold weather. But I've listened to the audiotape, and it didn't sound like that—it seemed to be as if something had thrown an object across the room.

At eighteen minutes, twenty-five seconds, one of the investigators was touched, with her hair being tugged on lightly. A few minutes later, while I sat underneath the steps (Harold's favorite hiding place), I felt like something pulled at my leg. I immediately looked down to investigate, but nothing was there. It was at that time that I noticed the dirt floor underneath the staircase. My mind wondered for a moment, thinking about the possibility of buried bodies. I'm not sure why. It just seems like that's where everyone buries their bodies. I shook the thoughts off, realizing that I had seen way too many horror flicks.

The same touching sensation occurred seconds later, this time on my back. It felt as if someone or something had tickled me. I checked for spider webs but found nothing. Then something felt like it was on my neck. At that same time, Tam mentioned that she thought she saw a shadow behind me. Strange indeed.

At about thirty-one minutes, fifty-eight seconds, Will asked, "Do you only try to scare people that are afraid of you?" A haunting, whispering voice quickly replied, "Yes." It should be noted that this seemed like a Class B EVP, as it was not entirely clear. A mysterious thud could be heard shortly thereafter, as if Harold perhaps tossed something in the darkness.

Will also had camera problems, which was similar to what I had experienced the previous time visiting the basement of the Opera House. Toward the end of the investigation in the basement, I could have sworn that I saw shadows running about, darting to and fro in the blackness. Also, the temperature began to fluctuate, dropping to nearly fifty degrees. Perhaps the spirits were finally comfortable with us and willing to come out and play.

But I promised you mummies in this chapter! Well, I won't disappoint you. But are they human or what? The picture here is that of a mummy, but what species is it? If you look closely, you can tell it is of an animal, a cat likely. This mummified cat was found in the walls of the basement on a recent cleaning of a back room. The question I have is if this cat is somehow related to the ghost cat stories. Could this mummy be the result of the paranormal feline incidents? Perhaps. And maybe now that the cat has been released from its hidden location in the back, its spirit is free.

The infamous mummified creature recently discovered in the basement of the Opera House.

Maybe there won't be any future ghostly cat stories, as it has moved on. Only time will tell.

With our expedition into the depths of the basement complete, we hastily moved on to the upstairs area, where the men's and women's dressing rooms were located. During our initial quiet time, I was sure that I saw shadow figures darting in and out of the back room. I made a comment about it, and Tam from TCPS confirmed what I saw—she had seen shadows as well, although hers seemed to be much taller. Were we seeing two entirely different entities? Perhaps the tall one was Ellen, the Victorian lady in white, mourning for her child lost to influenza—and possibly the smaller shadow was the child.

A few minutes after reviewing the videotape, I thought for sure that I had captured a full-body apparition. Finally my Holy Grail! Alas, after comparing it to audiotapes and other video, I confirmed that it was Will, who had moved from one location to another without me realizing it.

While asking if "you are Ellen," we heard a thump from nearby. I clearly remember hearing it while on the investigation. Yet in audio and video playback, no thump can be heard.

The main floor of the Opera House, with the balcony in the distance where shadow figures have been reported.

We tried the classic flashlight test, where we set a flashlight unscrewed enough as to have the light barely off. The theory is that the light is off but easy for a sprit to touch and energize it. Then we asked several questions, and while some of the questions appeared to get a lighted response, the majority of them did not. So for me, I would say that there is no obvious communication going on. Unless, of course, we were dealing with a playful spirit, one that enjoyed teasing us.

Also, while visiting the men's room in the back, the temperature dropped from sixty-five degrees to fifty-seven degrees. Could this be paranormal? Hard to say. But the normal operating temperature that night was definitely closer to sixty-five.

As for investigating the main floor, which contains the theater seats, balcony and stage, nothing out of the ordinary was experienced or captured. Well, initially I thought I had captured an apparition in a chair, but after a minute or two I realized that it was one of the TCPS investigators.

In the end, I would once again state that the Opera House is haunted. Did we get any concrete evidence? Not exactly. But the personal experiences solidified my belief once more. And for all of you doubters out there, why not stop by and watch a play? Maybe you'll get more than you bargained for.

Epilogue
# TRUTH BE FOUND?

So we've reached the end of the book, or at least I have. Hopefully you've enjoyed the journey as much as I have. I really wanted to focus on a number of things with this book. First of all, I wanted to provide you with a better understanding of the rich history in southern Minnesota, namely Mantorville. Hopefully I've shared enough and yet not too much as to bore you with details.

Any real paranormal investigator will tell you that it's critical to capture the important history of the building or location you are investigating. Research is critical, as it helps formulate and understand what may be happening paranormally. You need to understand the natural before you can truly comprehend the supernatural.

Secondly, I wanted to provide you with accounts of the many ghost stories from Mantorville. Trust me, there are many more not mentioned in this book. In fact, there are several more buildings with ghost stories associated with them. I may have only scratched the surface or revealed only the tip of the paranormal iceberg.

I hope, through all the ghost stories, that you can relate to a few of them. I doubt that any of them are that uncommon. They could have happened in any town. And with a little research, I'm sure that you could find some ghost stories in your neck of the woods. Perhaps not as many as Mantorville, but ghosts are universal—they seem to exist everywhere and have no bias.

This public domain image shows a lonely shack in the middle of nowhere.

It's possible, too, that Mantorville is not the most haunted town in Minnesota. Maybe it's just the most documented. Although, in much of the research I've done, I haven't come across a town littered with so many haunting stories in such proximity to one another. It's like I've said, there seems to be something else going on in this quiet little town off the Zumbro River—or something not so quiet, perhaps. Is it due to Native American curses? Or some demonic force deep within the earth? I have no idea. No research I did came to that direct conclusion. Then again, maybe I didn't dig far enough.

The third reason I wanted to write this book was to provide you with a firsthand experience of paranormal investigating. Perhaps not a *direct* experience, but through the details I've included you should have a better idea of what is involved with ghost hunting.

For many, the science of paranormal investigating is misunderstood. One might think that the field is full of crazy ghost people dressed in Goth clothing who live in their basements, only to come out when the sun sets. This couldn't be further from the truth. What I found the most amazing is that paranormal investigators are just people like you and me. They are accountants, police officers, computer programmers and

so on. The one thing they have in common that is different from most people is that they have an open mind and a passion for understanding the unknown.

Many of the paranormal investigators had ghostly experiences themselves when they were young. Now, as adults, they are very much interested in finding out what happened to them so long ago. Like a beacon in the darkness, they are driven to one fundamental goal: to solve the unsolvable.

I say "unsolvable" because that may, in fact, be the truth of the matter. This leads me to my final reason for writing this book: to find the truth about ghosts. I've had a handful of strange things happen to me when I was young, things that I can't explain with the known sciences of our age. To me, paranormal investigators are like the twenty-first-century Lewises and Clarks or Marco Polos. They are blazing through new territory—locations of science that as of yet cannot be tamed by our current knowledge and experiences.

The truth about ghosts may involve changing the rules about reality before we can begin to understand the problem. Being that ghosts may be otherworldly, a new and altogether different science may be required. This supernatural science has yet to be discovered. But who better to do so than those at the forefront of the paranormal battle. TCPS is just one of thousands of paranormal investigation teams. There are many like them,

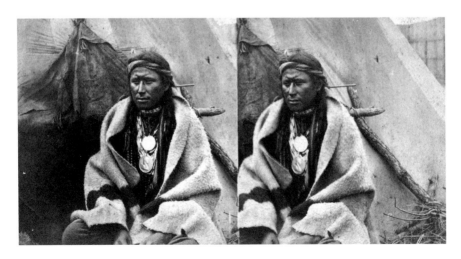

Native American sitting, public domain image. Could his spirit cause hauntings in the present day?

interested in understanding this new science. And with that, perhaps I will finally get my questions answered.

Still, there is something to be said about personal experiences. Sure, without tangible evidence like pictures, video and audiotapes, it's hard to prove that paranormal science is real. But in the mind of those experiencing the strangeness around them, an external source of evidence gives them little comfort. What makes them most pleased is in knowing that others have experienced their same confusion.

Regardless, I was pleased to capture several more personal experiences. There were several EVPs captured as well, which to me further help to fortify my questions about the paranormal. And the video from the Hubbell House gave me goose bumps, thinking that I may have caught a shadow creature on tape.

So did I find the truth about ghosts? Well, what do you think? I suppose it's more important that you answer that question. By reading this book, did you have any of your questions answered? Or maybe you're not on the ghostly fence anymore, resting comfortably on one side or the other. But have you decided to jump the fence? Have you tried looking at life from the other side? You may be surprised what you find.

As for me, no, I did not find the trifecta of paranormal experiences. I have no smoking gun nor the ultimate full-body apparition. But then maybe that's not the most important thing. Sometimes it's not what you get in life that matters—it's more about what you do with what you are given. I spent some fantastic time with the people of Mantorville in researching this book. I also got to hang out with some really cool paranormal investigators in TCPS. Most importantly, I was able to communicate and share these unusual ideas, these paranormal situations of life.

These supernatural situations are of life, not death. While they may stem from that which is dead, they are discovered and shared by the living. Perhaps that's what ghosts are really trying to do—they are not satisfied with being dead and would rather be like us, the living, once again. And through paranormal investigating, perhaps we are giving them that life.

So the next time you are home alone on the comfort of your couch, and you hear footsteps coming down the hallway, don't be alarmed. It's just the dead walking once again—trying to be alive. Stand up from the safety of your couch and face your fears. Who knows, maybe you will learn something from the ghost, just as it most likely will learn something from you.

The truth about ghosts is less about truth and more about people. Remember, ghosts were once people, too. They deserve to be respected;

they deserve your help. Why not help them? Perhaps you too could don the supernatural gauntlet and do some paranormal investigations yourself. Besides, what's the worst that could happen? You may jump from one side of the paranormal fence to the other. No big deal, right? It's just a fence.

# RESOURCES

Dodge County, Minnesota. www.co.dodge.mn.us.

Dodge County Historical Society. www.dodgecohistorical.addr.com.

Gaus, Marlene. *History of Mantorville, Minnesota, the County Seat of Dodge*. Mantorville, Minnesota: Mantorville Co-op Express, 1952.

————. *My Mantorville: 150 Years*. Dodge Center, MN: Community News Corporation, 2004.

*Hilltop Chronicle* newsletters. Located at the Dodge County Historical Society, Mantorville, Minnesota.

Hubbell House Restaurant. www.hubbellhouserestaurant.com.

Hunt, Ron, and Suzy Hoven. *Welcome Back to Mantorville*. Mantorville, MN: Hoven, 2007.

*Mantorville Express*.

Mantorville Theatre Company. www.mantorvillain.com.

Smith, H.A. *History of Dodge County*. Chicago, IL: H.H. Hill, 1884, reprint 2004, Dodge County Historical Society.

Town of Mantorville, Minnesota. www.mantorville.com.

# About the Author

Christopher Larsen is an award-winning author of children's and young adult short stories and novels. His interest in the paranormal started decades ago, and it still thrives today in the form of authoring several books. He currently lives in Rochester, Minnesota, with his wife, Nancy, and two boys, Zach and Alex. For more information, visit his website at www.cslarsen.com. He can be reached via email at chris@cslarsen.com.

Visit us at
www.historypress.net